POSTCARD HISTORY SERIES

Along Route 6 in Massachusetts

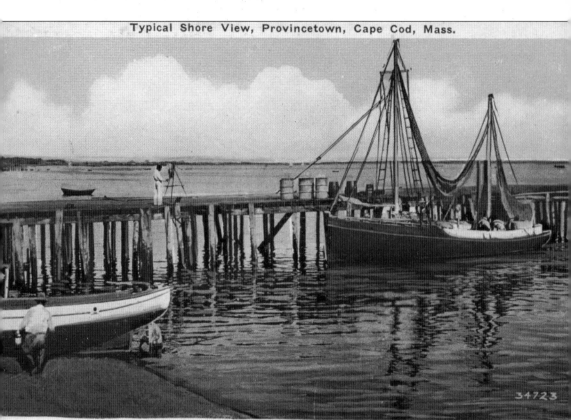

Typical Shore View, Provincetown, Cape Cod, Mass.

34723

This postcard shows an excellent view of two of Provincetown's mainstays: commercial fishing and painting. Since its very beginning, the town has been a major commercial fishing community. In the summer of 1899, when the Cape Cod School of Painting first opened, it ushered in the era of Provincetown becoming an art colony. (Author's collection.)

ON THE COVER: Cars drive along the newly paved Route 6 in Provincetown while beachgoers enjoy the pleasures of Cape Cod Bay. The main highway of Cape Cod, Route 6, begins in Provincetown and continues all the way to the Sagamore Bridge in Bourne. (Author's collection.)

POSTCARD HISTORY SERIES

Along Route 6 in Massachusetts

James A. Gay

ARCADIA
PUBLISHING

Copyright © 2017 by James A. Gay
ISBN 978-1-4671-2606-9

Published by Arcadia Publishing
Charleston, South Carolina

Printed in the United States of America

Library of Congress Control Number: 2016958542

For all general information contact Arcadia Publishing at:
Telephone 843-853-2070
Fax 843-853-0044
E-mail sales@arcadiapublishing.com
For customer service and orders:
Toll-Free 1-888-313-2665

Visit us on the Internet at www.arcadiapublishing.com

To my wife, Becky,
whom I have had the fun of exploring all these cities and towns with

CONTENTS

ACKNOWLEDGMENTS

I would like to thank Arcadia Publishing acquisitions editor Erin Vosgien, who gave me the opportunity to write this book. I also would like to thank my title manager at Arcadia Publishing, Caroline Anderson, who helped me put the pieces together chapter by chapter and was always there with suggestions, ideas, and feedback.

I would like to express my gratitude to the US Route 6 Tourist Association for the great work it does in preserving and promoting the storied history of US Route 6 from Massachusetts to California. I would like to thank the Fall River Public Library for allowing me to access its vintage postcards for this book.

In addition, I would like to thank all the historical societies or associations from all the cities and towns featured in this book. Finally, I would like to express my sincere gratitude to all my family and friends who helped in this project.

For clarification purposes on Cape Cod, the current Route 6A will be the actual Route 6 referred to in the book.

Unless otherwise noted, all images are from the author's collection.

INTRODUCTION

What was once a Native American trail on Cape Cod for centuries would one day be part of the longest highway in America. Beginning in Provincetown, the road would twist, turn, and run in various compass directions along the bayside of the Cape. It starts in Provincetown, where in the late months of 1620, a mixed community of separatists and opportunists on board the *Mayflower* first eyed the New World.

With provisions running low and many of them sick, they were in desperate need. A scouting party was sent ashore to explore the area, and the group included William Bradford. They found plenty of evidence of Native Americans living in the area and would indeed make contact in an unfriendly manner right near what would later become Route 6. When the group returned after one of its explorations, Bradford was given devastating news: his wife, Dorothy, the mother of his son still in England, had either slipped or intentionally jumped off the *Mayflower* and drowned in Provincetown Harbor.

The Pilgrims decided that the area was not suitable for their needs, so the *Mayflower* weighed anchor and sailed to their eventual home of Plymouth. The name *Bradford* would be forever linked to Provincetown, as in 1873, a new street was named after him. Decades later, Bradford Street would also be the new state road: Route 6.

In many ways, these saints and strangers would be linked to Route 6. Although settling in Plymouth, in later years, a group of them purchased land that would settle new communities that later became Fairhaven, New Bedford, Westport, and Dartmouth. In addition, the Pilgrims' successful venture made it possible for other groups, like the Puritans, to leave England and establish towns in the New World. These new arrivals started communities on the Cape that Route 6 would travel through. When the towns along the Cape increased in size, what was once a Wampanoag path became the major road linking all of them. First, the future Route 6 was widened and became the main road for stagecoaches on the Cape traveling from Provincetown to Bourne. It was called the "King's Road," and the name passed down from generation to generation; although, in the early 20th century, the Massachusetts state government and Cape Cod locals clashed over the name.

In 1920, an act of the General Court of Massachusetts officially designated Route 6 the King's Highway, and markers were placed along the road. This upset the locals greatly, especially those in Orleans who, after eight years of the annoyance, adopted a resolution in town meeting charging the state government with attempting, "neither historically nor geographically correct, to rewrite American history."

All the uproar over the naming of Route 6 attracted the attention of the major newspapers of Boston and one featured the headline "King's Highway Galls Cape Cod." Soon, other towns followed Orleans' lead and passed similar resolutions, with one community calling it "a deplorable situation." Then the resolutions were followed by outright destruction, as mysteriously, the King's Highway signs began to disappear. Once again, Orleans took the lead as the signs first started to disappear there and once again other town's signs began vanishing as well. Year after year, the fight continued as when new signs went up, they soon went missing.

Route 6 received its numerical designation when the Joint Board on Interstate Highways recommended a 75,884-mile US numbered system in 1925. The highway would start in Provincetown, continue following the King's Highway on the Cape, and then use the main roads connecting Wareham all the way to East Providence, Rhode Island. The joint board assigned even numbers to routes of prevailing east-west traffic; therefore, the proposed highway was given the number 6.

Since the highways were owned by the state, the US secretary of agriculture submitted the joint board's proposal to the American Association of State Highway Officials (AASHO) for approval. The proposal was approved by AASHO on November 11, 1926. In Massachusetts, what had been nothing more than a dirt road for stagecoaches was beginning to undergo a transformation, as it was paved and used by a brand-new mode of transportation: the automobile.

US Route 6 officially became a transcontinental highway on June 21, 1937. Traveling from Provincetown, Massachusetts, clear across the country to Long Beach, California, it became, at 3,652 miles, the longest highway in the United States. With the advent of the automobile, and the newly constructed Sagamore Bridge, Route 6 in Massachusetts ushered in Cape Cod's new industry: tourism. Along the road from Provincetown to Bourne, among the historic inns and taverns of stagecoach days, new gas stations and restaurants appeared.

To honor the Union forces of the Civil War, US Army major William L. Anderson Jr. proposed the idea of naming US Route 6 the "Grand Army of the Republic Memorial Highway." The Sons of Union Veterans of the Civil War embraced the proposition and soon began lobbying Anderson's idea in April 1934. Since the individual states owned the highways, the members met with state officials to officially adopt the name. Massachusetts governor Charles F. Hurley was the first to do so when he signed the bill into law on February 12, 1937.

One new change to the Cape after World War II that would dramatically change the numbers of cars on Route 6 was the building of the more modern Mid-Cape Highway in the 1950s. This new expressway would be given the designation of 6 while the original Route 6 would become 6A between Bourne in Orleans. Almost 40 miles in length, the new road offered an increased speed limit and saved considerable time, although it lacked the character and charm that former Route 6 offered. In addition, a more modern Route 6 was built in Provincetown and the original road was designated 6A.

In the early 1960s, Route 6 was no longer the longest highway in the United States. The State of California renumbered its state highways, and Route 6 no longer ended in Long Beach, but instead in Bishop. The change, which stands today, made US Route 20, at 3,345 miles, the longest highway and US Route 6, at 3,227 miles, the second-longest.

Although it might be faster to take the Mid-Cape Highway and Interstate 195 to Seekonk, if you have the time, I strongly suggest following Route 6 as it is laid out in this book. As it twists and turns, Route 6 offers both beautiful views and so much history that you do not want to miss it.

One

OUTER CAPE

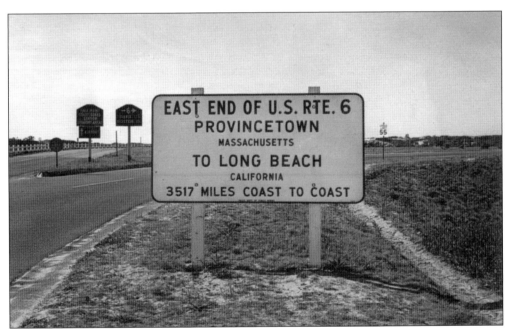

Route 6 travels from Provincetown to Seekonk before crossing into Rhode Island. At 3,652 miles, it was once the longest highway in the United States. When the State of California renumbered its roads in the early 1960s, Route 6 no longer ended in Long Beach, but in Bishop, California. As a result, Route 20 is the longest highway in America and Route 6 is the second-longest.

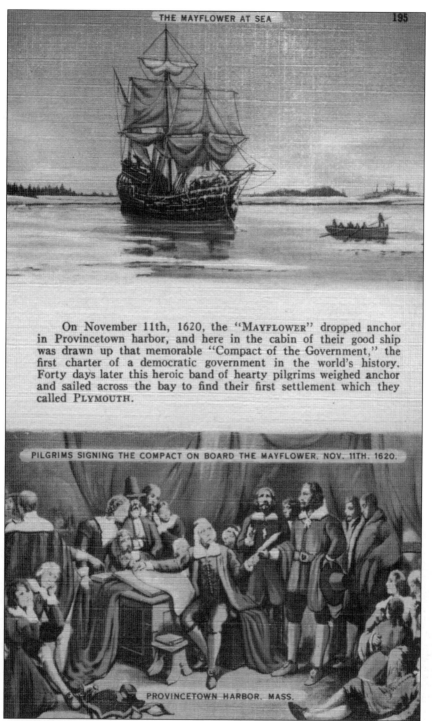

On November 11th, 1620, the "MAYFLOWER" dropped anchor in Provincetown harbor, and here in the cabin of their good ship was drawn up that memorable "Compact of the Government," the first charter of a democratic government in the world's history. Forty days later this heroic band of hearty pilgrims weighed anchor and sailed across the bay to find their first settlement which they called PLYMOUTH.

PILGRIMS SIGNING THE COMPACT ON BOARD THE MAYFLOWER, NOV. 11TH, 1620.

PROVINCETOWN HARBOR, MASS.

The beginning of Route 6 starts where the Pilgrims first set foot in the New World. On November 11, 1620, the *Mayflower*, carrying 102 passengers, rounded Long Point and dropped anchor in the harbor. While there, the Mayflower Compact was signed in the great cabin of the ship and exploring parties went ashore in search of a suitable location to live.

10

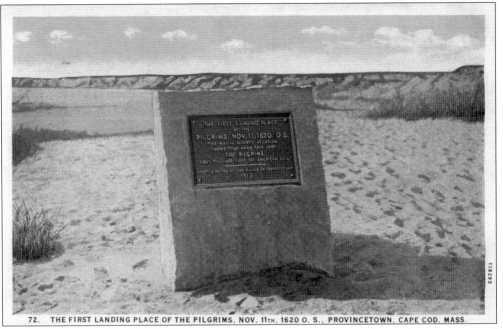

72. THE FIRST LANDING PLACE OF THE PILGRIMS, NOV. 11TH, 1620 O. S., PROVINCETOWN, CAPE COD, MASS.

Although no one can identify the exact spot with any certainty, the actual event is commemorated with a plaque and a park. Appropriately called Pilgrims' First Landing Park, it is located in the middle of a rotary at the end of Commercial Street.

149 State Road and Sand Dunes, Cape Cod, Mass

The birth of Route 6 can be traced back to October 1925, when the Joint Board on Interstate Highways proposed a 75,884-mile US numbered system. On June 21, 1937, Route 6 became a transcontinental highway extending all the way to Long Beach, California.

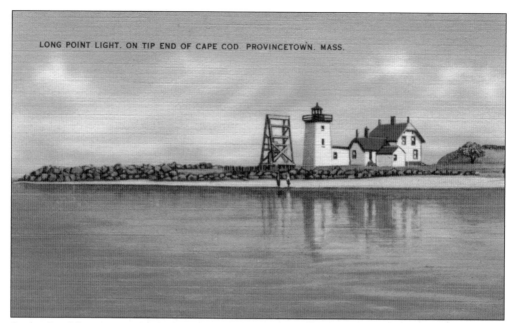

At the tip of the entrance to Provincetown Harbor sits Long Point Lighthouse. The first structure was built in 1827, but the spot where the lighthouse was located eroded over time, so a new lighthouse and dwelling was built in 1875. The light was automated in 1952, and it is still an active aid to navigation.

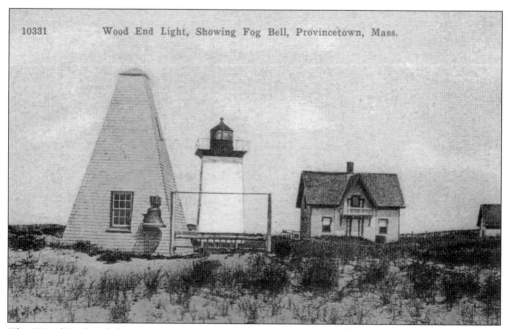

The Wood End Lighthouse went into service on November 20, 1872. At a height of 38 feet, the brick tower was first painted brown. The US Life-Saving Service built a station not far from the light in 1896. Automated in 1961, the light is still operational.

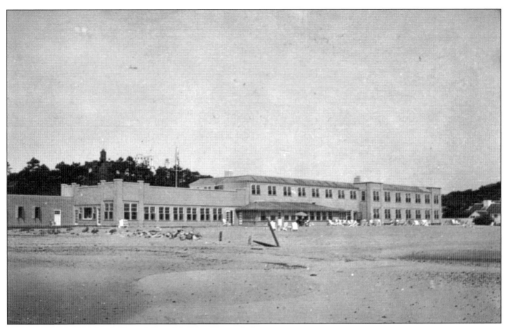

In the 1920s, Provincetown became a tourist destination for city dwellers from Boston and New York. The historic Provincetown Inn first opened in 1925 with 25 guest rooms and a formal dining room. In the late 1950s, the inn's longtime owner, Chester Peck, decided to expand the premises. Using rocks and sand from a nearby dune, Peck created a peninsula upon which motel rooms were built on.

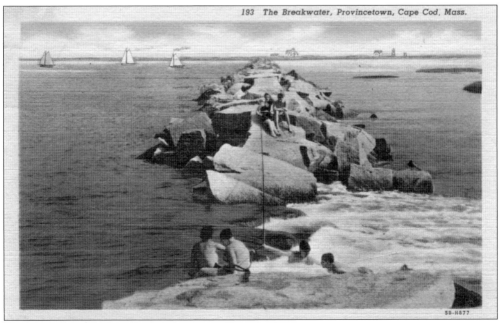

193 The Breakwater, Provincetown, Cape Cod, Mass.

Located near the junction of Commercial Street and Route 6 is the Provincetown Breakwater. It was built in 1911 by the US Army Corp of Engineers to prevent sand from washing into the harbor. One may walk across the breakwater to Wood End Lighthouse.

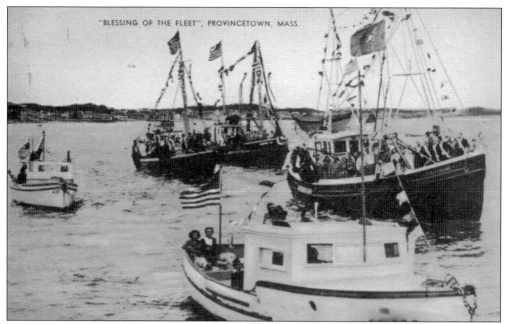

Commercial fishing was Provincetown's first major industry. With so little land for farming and surrounded by water, Provincetown's citizens' obvious choice of employment was fishing. In 1947, Provincetown's first Blessing of the Fleet was conducted by Bishop James E. Cassidy, and the tradition is carried on to this day.

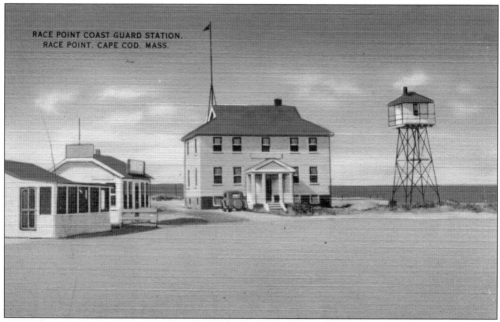

On the outer tip of Provincetown is Race Point Beach, scene of hundreds of wrecks as offshore rips and tidal currents are extremely treacherous. The first US Life-Saving Service station here was built in 1873 and replaced by this Coast Guard station in 1931. In the late 1970s, the Coast Guard left Race Point and built a new station on the harbor.

14

A lighthouse was first established at Race Point in 1816, and in 1876, a new 45-foot tower was built. Today, a nonprofit organization, Cape Cod Chapter of the American Lighthouse Foundation, maintains the lighthouse and guests can stay overnight in the keeper's house or whistle house.

Today, the area is part of the Cape Cod National Seashore, where visitors can hike trails and stop in at the Province Lands Visitor Center. On a clear sunny day, the observation deck provides wonderful 360-degree views.

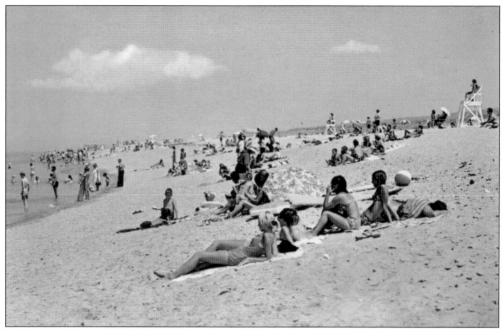

Beachgoers enjoy a relaxing day at Race Point Beach in Provincetown. The National Park Service maintains and operates six public beaches within the Cape Cod National Seashore. Besides Race Point, there are Coast Guard Beach, Nauset Light Beach, Marconi Beach, Head of the Meadow Beach, and Herring Cove Beach.

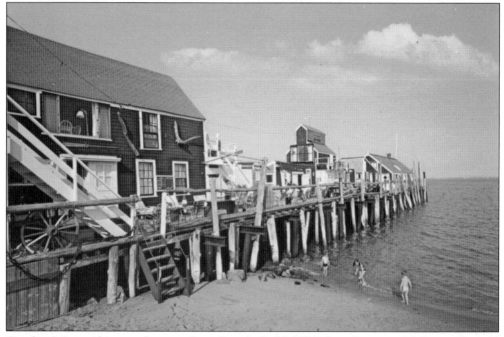

Condominium cabins can be rented on Captain Jack's Wharf on Commercial Street. Born in Provincetown in 1861, Jackson R. Williams was a fisherman in the 1880s and, by the turn of the century, had built a 200-foot wharf and rented pier sheds and shacks to tourists.

Among the picturesque sand dunes of Cape Cod grow hundreds of patches of small bushes known as bayberry bushes. Each shrub, which is a variety of the wax myrtle, is loaded with clusters of tiny berries.

A Cape Cod Bayberry Bush, from which the famous Cape Cod Bayberry Candles are made, Provincetown, Mass.

One of the first vessels strictly dedicated to ferry service was the *Longfellow* in 1883, and she continued in operation until 1902. One of the most famous steamships was the *Steel Pier*, purchased by the Cape Cod Steamship Company in 1934. On July 26, 1936, she made her first landing on Monument Dock in Provincetown carrying 1,400 passengers. She was replaced by the *Holiday* in 1948.

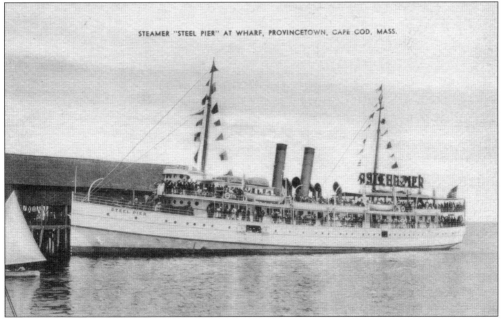

STEAMER "STEEL PIER" AT WHARF, PROVINCETOWN, CAPE COD, MASS.

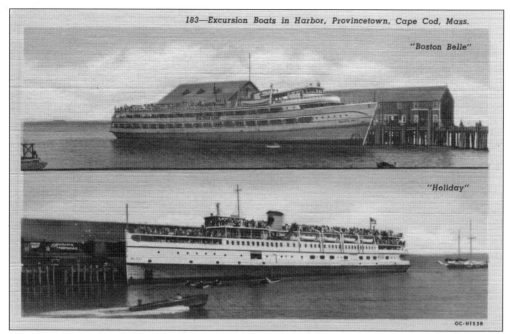

183—Excursion Boats in Harbor, Provincetown, Cape Cod, Mass.

"Boston Belle"

"Holiday"

The *Steel Pier* was replaced by the 291-foot *Holiday* in 1948, and she ran between Boston and Provincetown in the summers of 1949 and 1950. The *Holiday* was replaced by the *Boston Belle*, built in 1949, which began running between Boston and Provincetown in 1951. She could carry over 3,000 passengers and make the trip in three and a half hours.

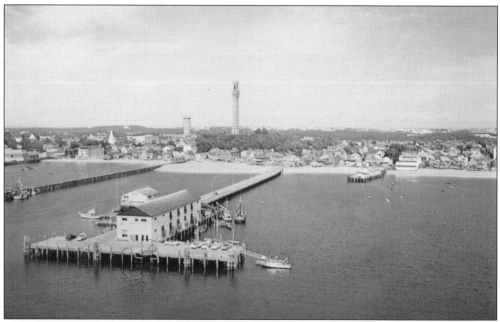

MacMillan Wharf, also called Town Wharf, is named after Provincetown native and hometown hero Rear Adm. Donald B. MacMillan. The wharf was built beginning in 1955 and in July 1957 Rear Admiral MacMillan officially opened the pier to the public during a ribbon-cutting ceremony.

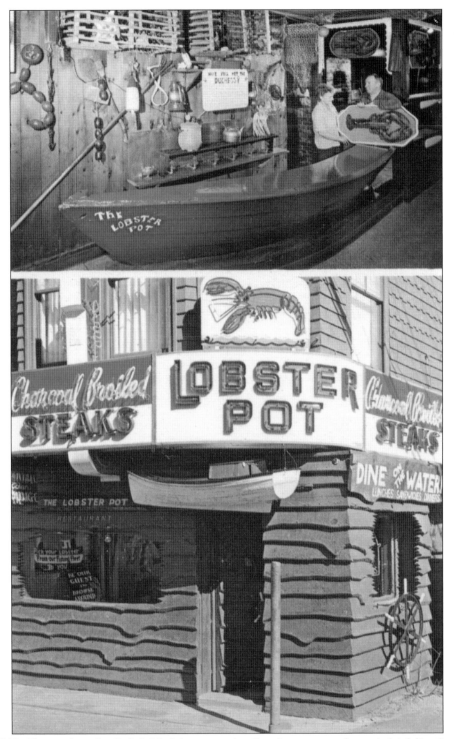

In 1938, Plymouth native Ralph Medeiros moved to Provincetown and married Adeline Santos. In 1943, the two opened the Lobster House Restaurant on Commercial Street, and it is still open today. The Top of the Pot, a second-floor bar, lounge and dining room, opened in 1990.

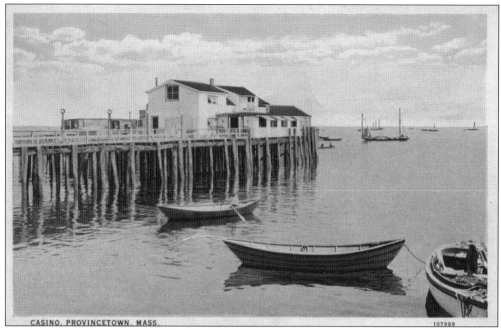

CASINO, PROVINCETOWN, MASS. 107989

Not far down from MacMillian Wharf on Commercial Street was the George O. Knowles Wharf, named after a native who operated three whalers. Later renamed Higgins' Wharf, it was home to one of the first restaurants and nightclubs in Provincetown, the Casino.

Bradford Street, named for Pilgrim William Bradford, is another name for Route 6 as it runs through the heart of Provincetown. The street was first laid out in 1873, and it soon opened for public travel. It passes directly in front of High Pole Hill, where the Pilgrim Monument is located.

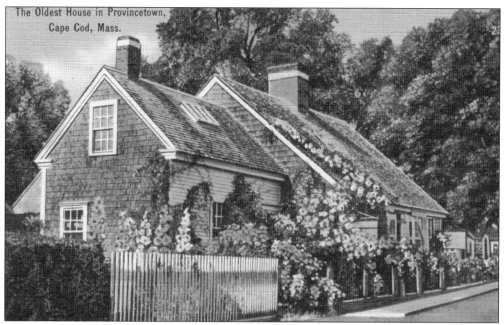

The Seth Nickerson House, considered the oldest house in Provincetown, was built on Commercial Street in 1746. Nickerson was a ship carpenter, and a part of the house was made from wood collected along the beach from shipwrecks. The center brick chimney weighs 16 tons and was built on top of crisscrossed logs to prevent it from sinking into the sand.

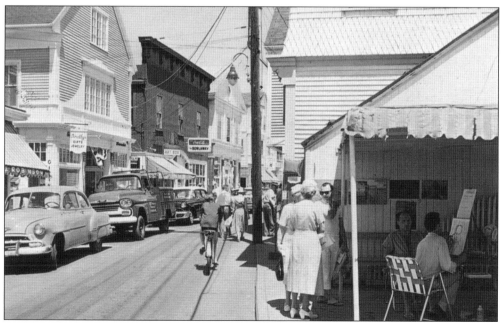

Commercial Street runs parallel to Route 6 and along the waterfront all the way into North Truro. It is filled with shops, restaurants, and motels. In the right-hand side of this postcard, an artist works on a charcoal sketch.

In 1892, the Cape Cod Pilgrim Memorial Association was incorporated to preserve and commemorate the Pilgrims' historical ties to Provincetown. In 1902, the town deeded the use

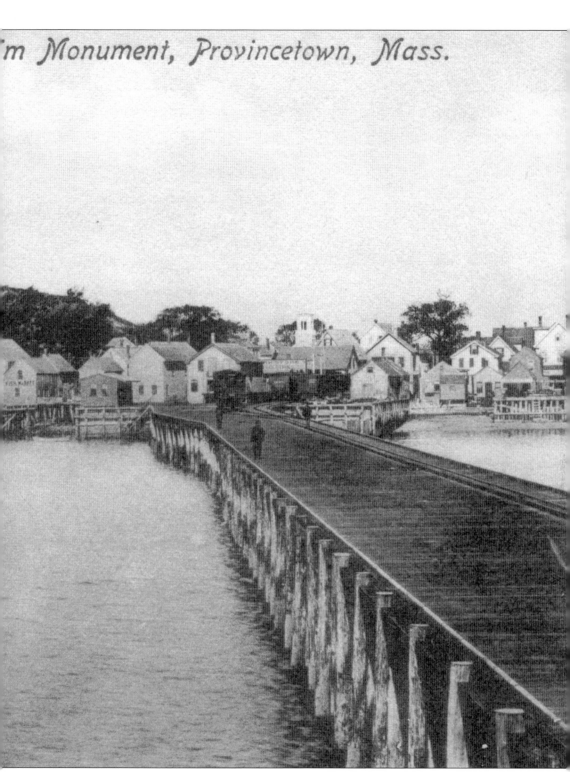

of High Pole Hill for a monument honoring the Pilgrim's arrival in Provincetown.

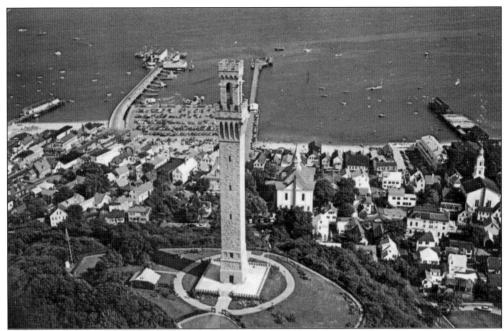

The association raised $92,000 for the construction of the monument, and it would be designed after the Torre del Mangia in Siena, Italy. The association chose prominent Boston architect Willard T. Sears to design the monument.

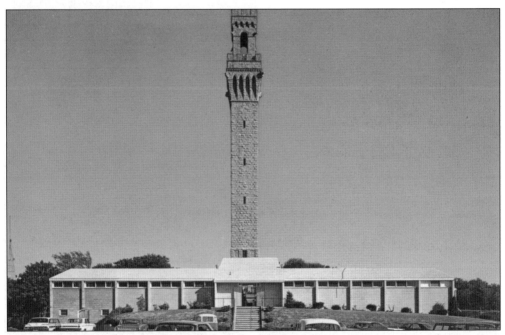

The dedication of the completed monument was held on August 5, 1910. Pres. William Taft spoke to the assembled crowd, and after the ceremony, a dinner was held at the town hall. The tower is 252 feet and is the tallest all granite structure in the United States. (Courtesy of Connie Rizoli.)

Located in the shadow of the Pilgrim Monument on the Town Green is the monument depicting the signing of the Mayflower Compact. Known as the Bas-Relief, it is 16 feet by 9 feet and was designed by Cyrus E. Dallin of Boston and cast by the Gorham Corporation of Providence, Rhode Island.

Guests enjoy a spectacular view atop the Gifford House Inn on Carver Street. Although the date of its official opening is a bit murky, it was in full operation at least by the 1860s. To this day, the inn retains the name of its original owner, James Gifford.

PILGRIM MEMORIAL MONUMENT AND BAS-RELIEF TABLET,

PROVINCETOWN, CAPE COD, MASS.

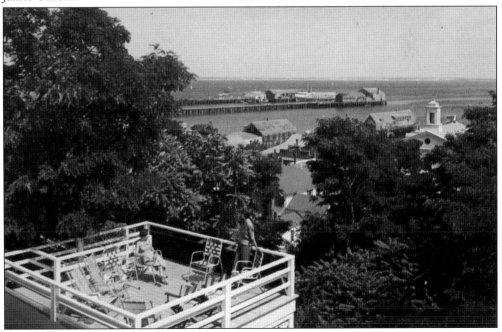

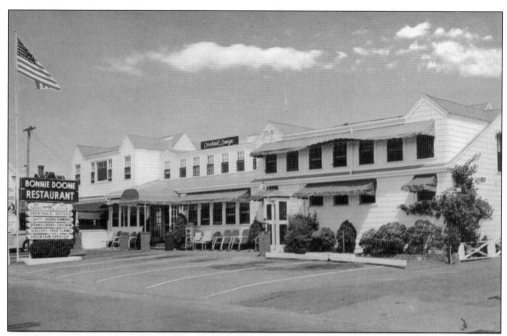

In 1937, Manuel and Mary Cabral opened the Bonnie Doone Grille (later renamed Bonnie Doone Restaurant) on Route 6. In the 1950s, the Thistle Cocktail Lounge was very popular, and the restaurant stayed in the family for three generations. Today, the old Bonnie Doone site is the Mussel Beach Health Club.

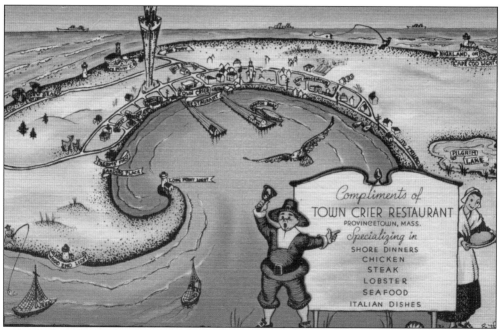

Located on 294 Commercial Street was the Town Crier restaurant. Today, it is the Coconuts Sunglasses Shop. Diagonally across the street is the Provincetown Portuguese Bakery. By 1860, the town had a significant Portuguese population.

The Cape Colony Motel was built in 1963 and owned for almost 30 years by Dennis and Carole Still. "Motel" has been replaced with "Inn," and it has been newly renovated.

The Moors Restaurant was opened in 1939 by Maline N. Costa. After a fire in 1956, it was subsequently rebuilt. One could dine on delicious Portuguese food in the Combed from the Sea restaurant or enjoy spirits in the Smuggler's Jug Room.

Built in 1917, this former rooming house was bought by Alden and Clotilda Steele in 1965 and became the Casa Brazil Lodge. It offered guests 30 rooms and 10 apartments, and today, the front building is the Elephant Walk Inn.

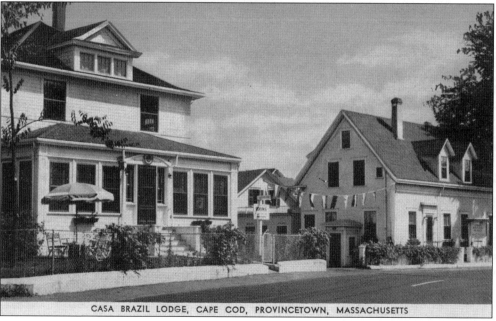

CASA BRAZIL LODGE, CAPE COD, PROVINCETOWN, MASSACHUSETTS

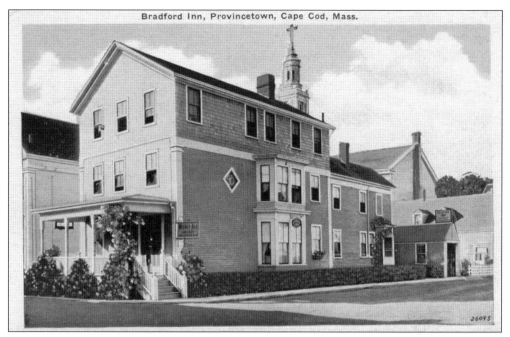

Bradford Inn, Provincetown, Cape Cod, Mass.

The main house of the Bradford House and Motel was built in 1888 by Reuben F. Brown, a coal and lumber merchant. During World War II, his son sold the house to Thomas and Anna Cote, who opened the Bradford House and, in 1950, added a one-story wing.

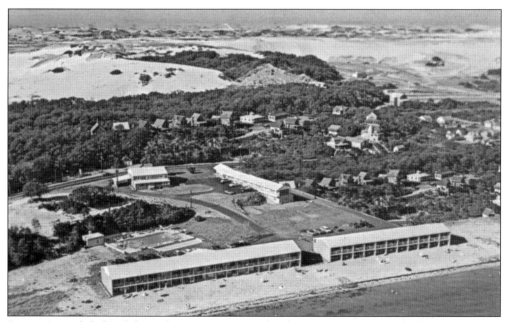

Route 6 travels behind the Tides Motor Inn as it heads to Truro. In 1955, the location was the site of the Prescott Cottages, owned and operated by Joseph and Cathryn McCabe. The Tides was built in 1961 and offered the use of a 500-foot private beach. Today, the property is the Bay Harbor Condominium Complex.

29

The Surfside Hotel and Suites was built in 1964. First painted emerald green, it soon became known as the "Green Monster." The height of the building caused such an outrage in town that a new zoning bylaw was passed to limit the height of future buildings to 35 feet.

Built in the 1940s, the Provincetown Municipal Airport lies within the Cape Cod National Seashore and consists of a single runway. Provincetown-Boston Airlines was founded in 1949 by John C. Van Arsdale.

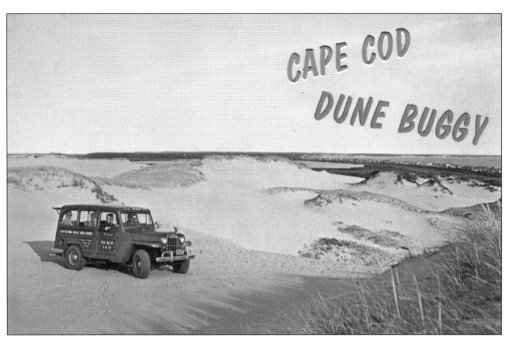

In 1946, Art Costa started Arts Dune Tours using a 1936 Ford Woody. Today, Arts Dune Tours is run by Art's son Rob and tours are given April through November.

The Holiday Shores Motel, managed by Edward and Julia Martin in the 1950s, was located a mile and a half from Provincetown Center. Today, it is the Holiday Shoreline Condominium complex.

Studio Gardens, Provincetown, Cape Cod, Mass.

By 1914, Provincetown was a haven for artists, writers, and those who embraced the bohemian lifestyle. Art organizations were formed, such as the Beachcombers Club and its female equivalent, the Sail Loft Club. Art schools were opened for either traditionalist or modernist students.

From Provincetown, Route 6 crosses into the town of Truro. The northern section of what became the town was explored by the Pilgrims while they were searching for a suitable site to live, and William Bradford was caught in a Native American deer trap. The 50-room Buccaneer Motel used to be run by Bob and Flo Roman in North Truro. Today, it is the Blue Sea Motor Inn and the pool is enclosed.

Truro was home to the Pamets, a group of the Nauset Nation and from which the Pamet River derives its name from. Cape Cod Fishnet Industries was a longtime employer from its opening in 1935 until its closing in the 1970s. Founded by Ada Elizabeth "Tiny" Worthington, the company made clothing from fishing nets.

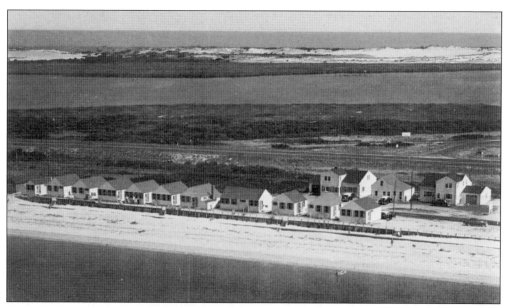

Truro was incorporated as a town in 1709 and named after Truro in Cornwall, England. White Village Cottages in North Truro offers a private beach and fully equipped cottages that can accommodate two to six guests each.

Built in 1827, this Congregational church is the oldest house of worship on the Outer Cape. Listed in the National Register of Historic Places, the church still has its original bell cast by the [Paul] Revere Foundry in Canton, Massachusetts.

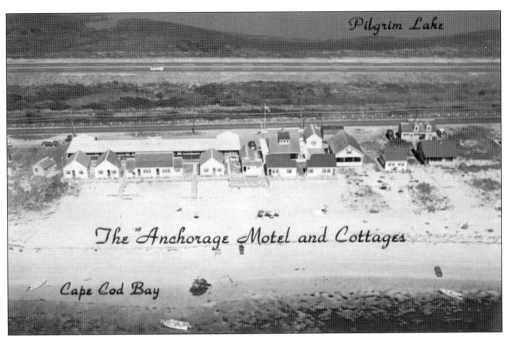

Pilgrim Lake

The Anchorage Motel and Cottages

Cape Cod Bay

Gentlemen from Truro were sent to the island of Nantucket to teach the locals how to kill whales and blackfish. The Anchorage Motel and Cottages on Route 6 in Truro offered two- and four-room units on a private beach.

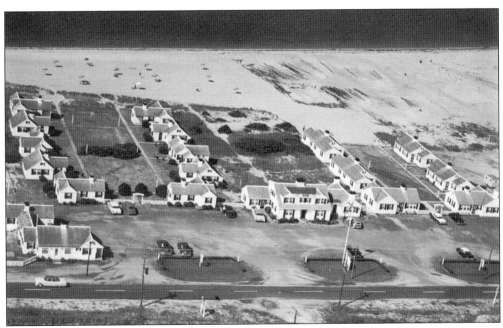

Some of the early industries of the town were fishing, shipbuilding, and saltworks. Kalmar Village is a cottage colony that has been open to tourists since the 1940s. Still in business today, it has been owned by the same family for the last 45 years.

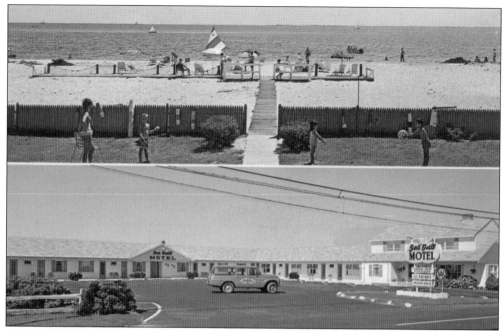

Since 1958, the Sea Gull Motel was a second home to many vacationers during the summer months. The Sea Gull officially closed at the end of the 2015 summer season due to the changing rental industry.

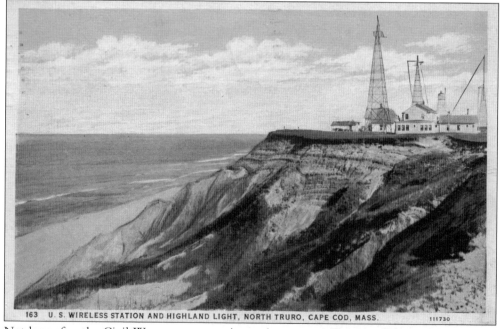

163 U. S. WIRELESS STATION AND HIGHLAND LIGHT, NORTH TRURO, CAPE COD, MASS. 111730

Not long after the Civil War, passenger train service came to Truro and the summer tourists would soon arrive in town. This is a 1920s postcard of the US Wireless Station and Highland Lighthouse. In 1797, Isaac Small sold the government 10 acres of land to build the first lighthouse on Cape Cod.

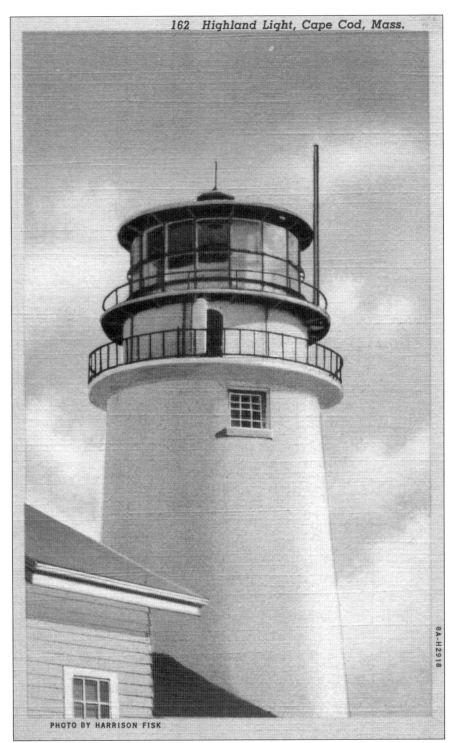

PHOTO BY HARRISON FISK

Located on a 125-foot-high clay cliff, the present brick tower was built in 1857. The famous author and naturalist Henry David Thoreau made several visits during the 1850s. The light was automated in 1987 and is a current aide to navigation.

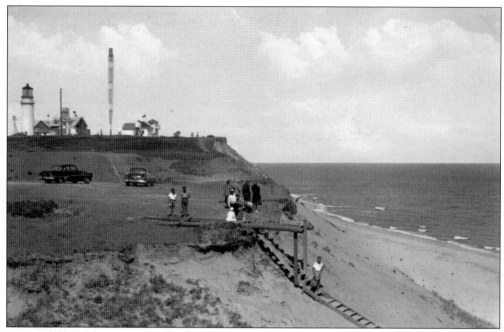

Due to the erosion of the cliff, the lighthouse was moved 450 feet back in 1996. Seasonal tours are given by a dedicated staff, and visitors can climb the 69 steps to the top of the light.

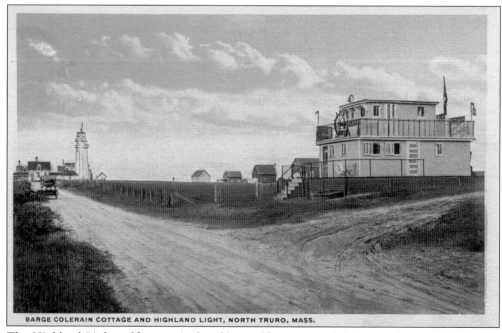

BARGE COLERAIN COTTAGE AND HIGHLAND LIGHT, NORTH TRURO, MASS.

The Highland Links golf course is the oldest golf course on the Cape and was established in 1892. A barge that had washed ashore below the cliffs served as the clubhouse.

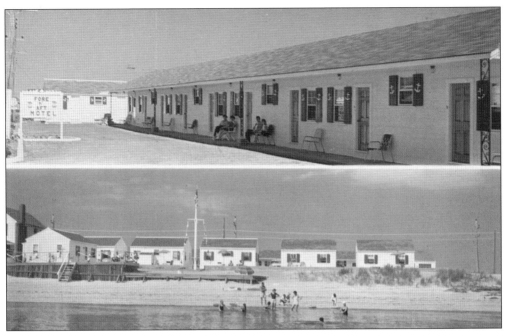

The Fore 'N' Aft Motel and Cottages was built in 1945, and guests could enjoy the sundeck and a 300-foot private beach. Today, the motel and cottages still stand but are run-down and vacant.

When President Kennedy created the Cape Cod National Seashore in the early 1960s, it preserved almost two-thirds of Truro in its natural state. The Pilgrim Colony Cottages on Route 6 has six cottages with fireplaces and a 400-foot private beach.

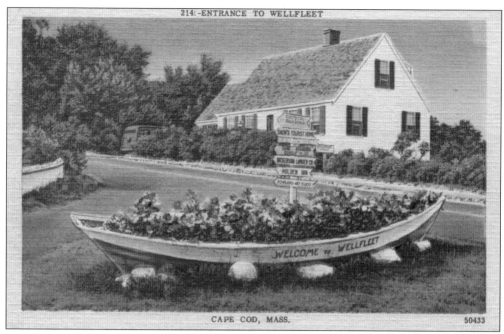

CAPE COD, MASS. 50433

Shortly after Route 6 crosses the Herring River, it enters the town of Wellfleet. In the early 1640s, fishermen from Plymouth and Duxbury discovered good grounds in what would become Wellfleet Harbor. The area first became settled during the 1650s.

Wellfleet was incorporated in 1763 and named after the Wellfleet oysters harvested off the eastern shores of England. Main Street in Wellfleet can be accessed directly off Route 6. With a population of 3,500 year-round residents, the population can increase to almost 17,000 during the summer months.

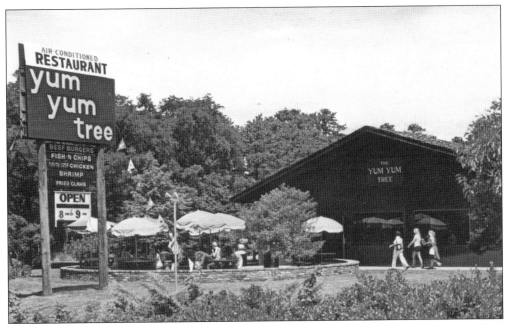

The Yum Yum Tree Restaurant on Route 6 in Wellfleet, a self-service family restaurant, specialized in seafood and was open from Memorial Day to Columbus Day. Known for its "Sunday Flipper Breakfast" served every Sunday from 8:00 a.m. to 11:00 a.m., the restaurant no longer exists.

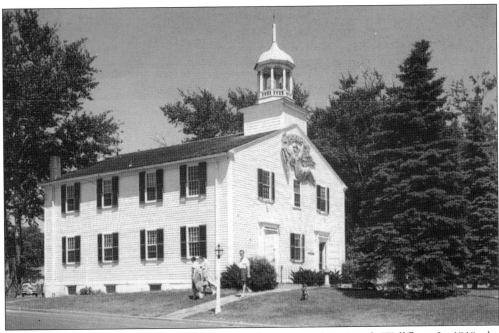

The town hall was once the Second Congregational Church in South Wellfleet. In 1919, the building was moved to the center of town to be used as Memorial Hall. In 1960, the hall burned to the ground, but it was rebuilt in 1961.

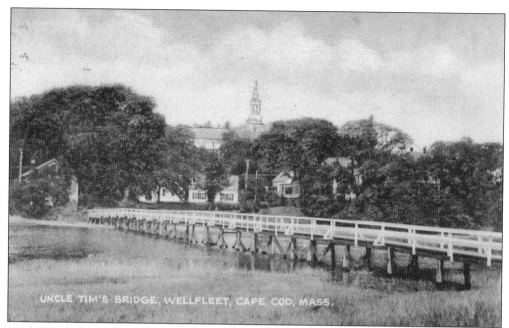

Uncle Tim's footbridge was known as the new bridge in 1783. Crossing over Duck Creek, it connects the central village of Wellfleet to Hamblen Island and is named after Timothy E. Daniels. Known as "Uncle Tim," he had a shop directly across from the bridge in the 1800s.

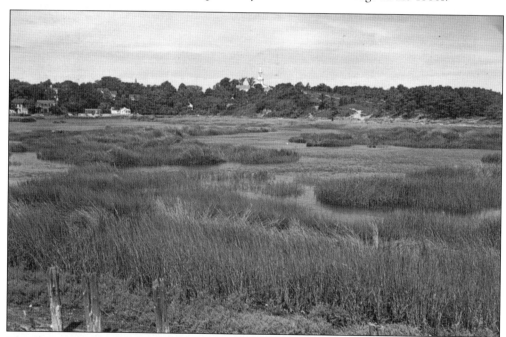

The town center can be seen in the background of this postcard of the marshes. The town is also home to a 1,000-acre Massachusetts Audubon Society Wildlife Sanctuary. In the early 1700s, an immigrant from England named Samuel Bellamy made his way down from Provincetown and arrived in Wellfleet. Falling in love with a local girl named Maria Hallett, he set sail to attempt to recover gold from sunken Spanish ships off Florida.

Bellamy was too late to retrieve gold from the sunken ships and eventually became a pirate. Sailing back from the Caribbean as captain of the *Whydah*, he and most of his crew were killed in a nor'easter off Wellfleet in 1717. The First Congregational Church of Wellfleet is located right on Main Street. The community of faith traces its beginnings back to 1721.

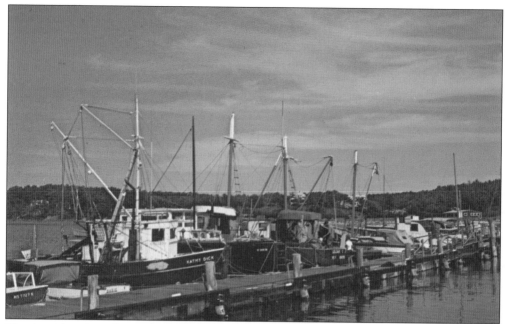

The American Revolution ended the town's whaling days but gave rise to its fishing industry. Since the Royal Navy had instituted a blockade, no ships were able to leave the harbor so they rotted at the piers. After the war, there was no money to invest in rebuilding the whaling industry. By the 1800s, Wellfleet was one of the leading fishing ports in Massachusetts. These fishing draggers are tied up at the town pier.

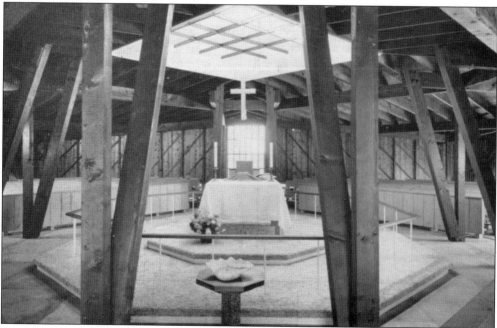

Farther south, Route 6 passes right by the Chapel of St. James the Fisherman Episcopal Church. The congregation first met from 1950 to 1956 at the Wellfleet Congregational Church and worked closely with architect Olav Hammarstrom to build their own chapel.

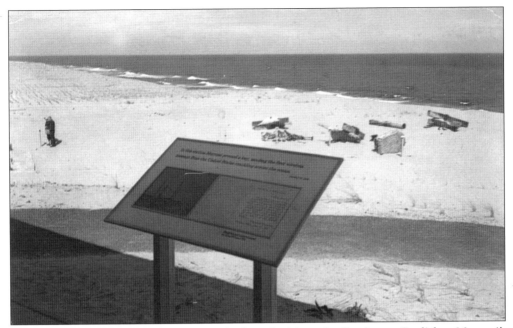

This marker designates the 1903 location of Italian physicist and radio pioneer Guglielmo Marconi's wireless station on the back side of Wellfleet. It was from this spot that the first transatlantic wireless communication between the United States and England took place.

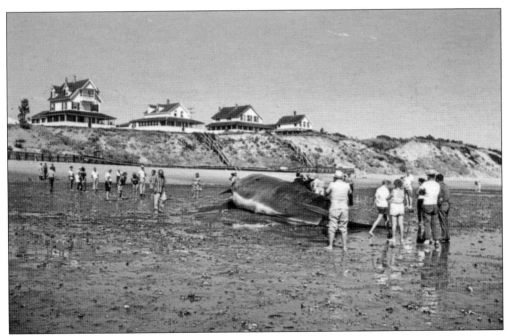

A whale lies washed up on Mayo Beach on the bayside. Wellfleet Harbor and the Breakwater Light can be seen from the beach. Wellfleet's tourism industry began when L.D. Baker constructed the Chequesset Inn on the pilings of the abandoned Mercantile Wharf in 1902.

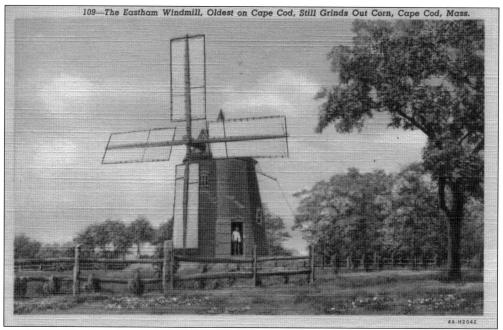

109—The Eastham Windmill, Oldest on Cape Cod, Still Grinds Out Corn, Cape Cod, Mass.

Route 6 crosses over Hatches Creek and enters Eastham. The Eastham Windmill is the oldest on the Cape and was first built in Plymouth, Massachusetts, in 1680. The windmill is located right off Route 6 on the Eastham Village Green and is open to the public in the summer.

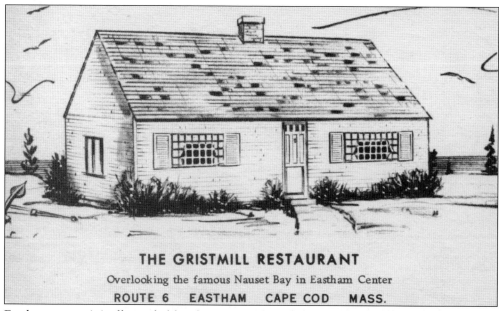

THE GRISTMILL RESTAURANT

Overlooking the famous Nauset Bay in Eastham Center

ROUTE 6 EASTHAM CAPE COD MASS.

Eastham was originally settled by the Nauset. Later inhabited by families from Plymouth Colony, it was incorporated as a town in 1651. Located directly on Route 6 was the Gristmill Restaurant, but it eventually closed. The building later became an antique store named the Gristmill Gallery.

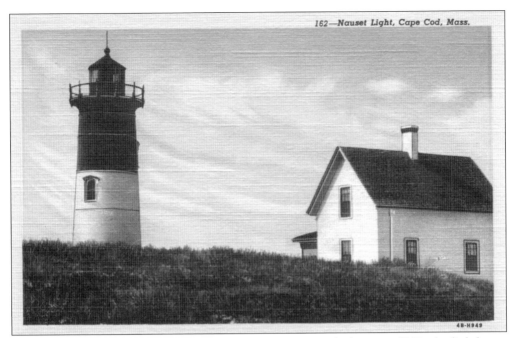

Nauset Lighthouse, built in 1877, was actually located in Chatham. In 1923, the lighthouse was moved to Nauset and was located much closer to the ocean than it is today. In 1996, it was moved 300 feet back to its present location due to cliff erosion.

As Route 6 crossed into Orleans, it passed right by Cranberry Cove. The amusement attraction offered ice cream, miniature golf, archery, a gift shop, and pitch and putt golf. Orleans was settled in 1644 and incorporated as a town in 1797. The tourism industry began in the town with the arrival of the railroad in 1865.

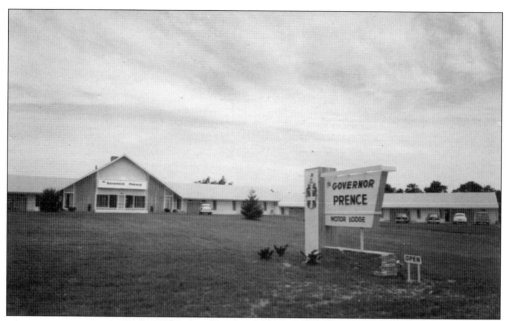

The Governor Prence Motor Lodge (now Inn) is located right off Route 6 in Orleans. Although it once was open all year-round, the Prence offers only seasonal availability today. During the War of 1812, British marines from the HMS *Newcastle* attacked Orleans but were beaten back by the local militia.

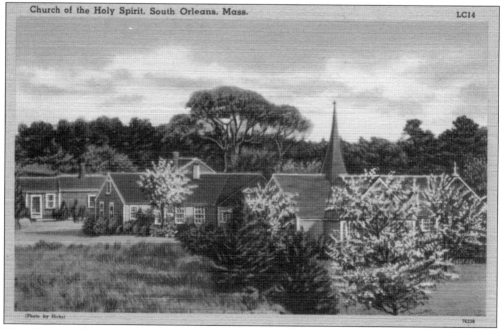

The Church of the Holy Spirit was founded in 1933, and the first structure was built from the remnants of a building damaged by a hurricane. Although altered with additions and renovations, the buildings still serve parishioners.

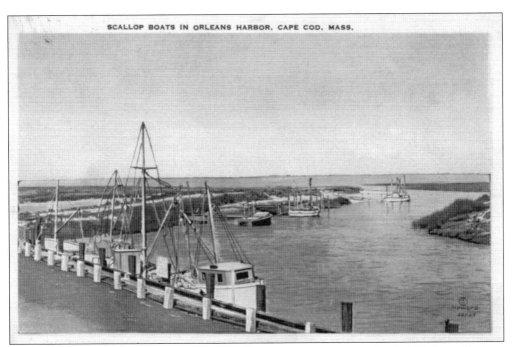

SCALLOP BOATS IN ORLEANS HARBOR, CAPE COD, MASS.

An eastern-rigged scallop boat lies at anchor in between trips in this sketch of Orleans Harbor. Since the earliest days, Rock Harbor has been the town's center of maritime commerce and history. Today, there is a large charter boat sportfishing fleet that caters to tourists.

Orleans High School, Orleans, Cape Cod, Mass. LC13

Before the creation of the Nauset Regional School System, students in Orleans went to their own high school. Today, the building is the Nauset Regional Middle School. In July 1918, a U-boat fired at the tug *Perth Amboy* and four barges in the Nauset area.

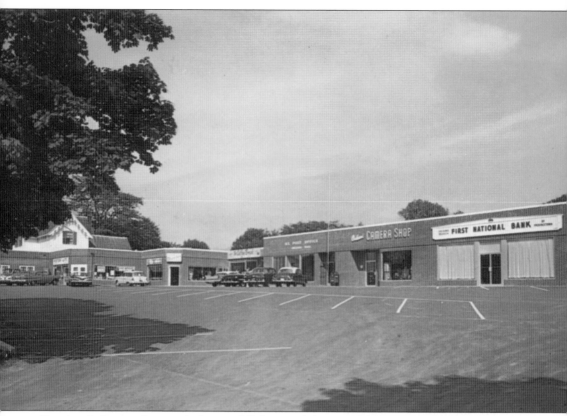

Tourism is the number one industry of Orleans as it is part of the Cape Cod National Seashore and has freshwater beaches as well. This postcard shows a portion of the Orleans Shopping Center featuring the First National Bank of Provincetown, a camera shop, and the US post office.

Two

MID-CAPE

The sea-gull's cry rings in my ears,
As o'er the foam he flies,
And memory sets her signal lights
Along the darkened skies.

188 SEA GULLS, CAPE COD, MASS. 123038

Route 6 passes underneath the Mid-Cape Highway in Orleans and then enters the town of Brewster. It continues running parallel to Cape Cod Bay as it twists and turns through the towns of Dennis and Yarmouth.

As Route 6 enters Brewster, it passes through Nickerson State Park. With almost 2,000 acres, the park offers both walking and bicycle paths. It also has over 300 kettle ponds, formed when glaciers retreated from Cape Cod.

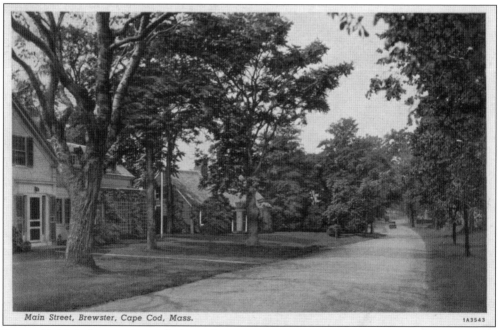

Main Street, Brewster, Cape Cod, Mass. 1A3543

Route 6 is Main Street as it travels through Brewster. The town is named after William Brewster, one of the original Pilgrims who arrived aboard the *Mayflower*. It is nicknamed "the Sea Captain's Town," as many sailing captains built wealthy homes here in the 1800s.

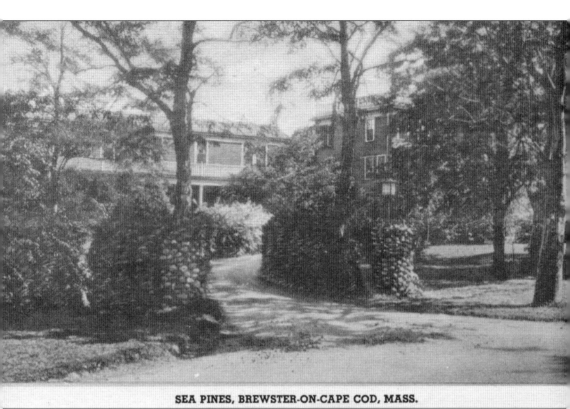

SEA PINES, BREWSTER-ON-CAPE COD, MASS.

Located directly on Route 6, the Sea Pines School of Charm and Personality for Young Women was founded in 1907 by Rev. Thomas Bickford. Stephen and Michele Rowan bought the property in 1977 and have been running the Old Sea Pines Inn ever since.

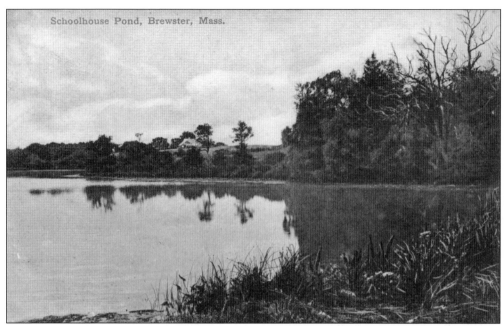

Schoolhouse Pond, Brewster, Mass.

School House Pond is located right off Route 6 and is surrounded by private homes, seasonal cottages, and beaches. There is a small deck for fishing or viewing the scenery. The pond has been stocked with fish over the years, and the public can access boat ramps.

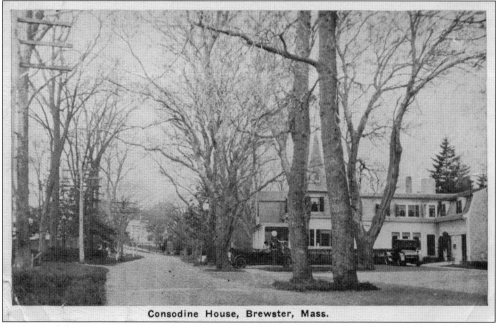

Consodine House, Brewster, Mass.

Built around 1870 and first used as a retirement home, this structure was purchased by John and Clara Consodine in 1895. They ran it as an inn for the next 56 years and grew their own fruits and vegetables. Although no lodging is provided today, it is currently the Brewster Inn & Chowder House.

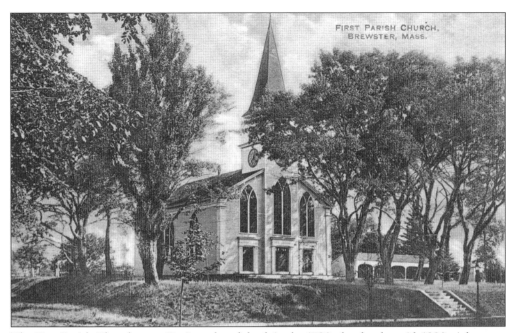

The First Parish Church was a Puritan church back in the 1700s, but by the mid–1800s, it became a Unitarian house of worship. Built in 1834, this is the third building erected on this spot. With the merger of Unitarians and Universalists in 1961, it is today the First Parish Brewster Unitarian Universalist Church.

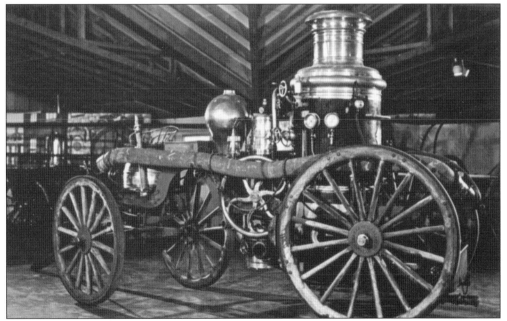

The New England Fire & History Museum once housed New England's largest display of firefighting equipment and memorabilia. The museum consisted of six buildings with 35 historical fire engines. Included in the exhibits was the only existing 1929 Mercedes-Benz fire truck in the world; unfortunately, the museum closed, and the property is being used for other purposes today.

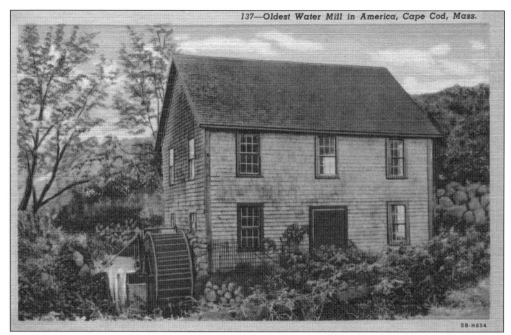

The Stony Brook Grist Mill is located at the intersection of Satucket and Stony Brook Roads. It was built on the fulling and woolen mill foundation in 1873. Bought and owned by the Town of Brewster in 1940, it is open as a museum between June and August.

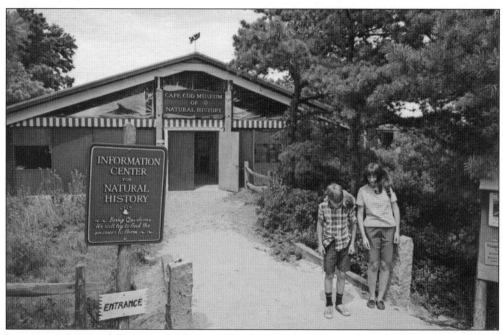

Brewster is home of the Cape Cod Museum of Natural History, which has been located at its present location since the 1960s. Through the museum's exhibits, public education programs, and stewardship of over 400 acres of land, visitors can learn about the various animals, plants, and marine life that call Cape Cod home.

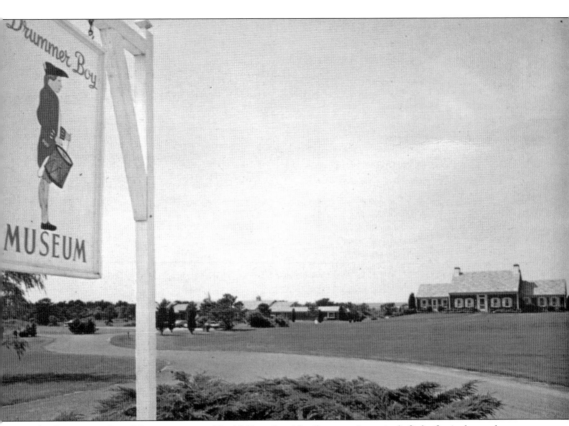

The Drummer Boy Museum opened in 1961 and paid tribute to America's fight for independence. The building was the size of a football field and featured 10-foot-high oil paintings complemented with sounds and lights. An early attempt at living history, it is no longer open.

Greetings from the Town of Dennis, on Cape Cod

This marker designates the location of the Shiverick Shipyard in East Dennis. In 1815, Asa Shiverick launched his first schooner and later would build eight clipper ships. The names of the ships are listed on this plaque, and Dennis was the only town on the Cape that would build clipper ships.

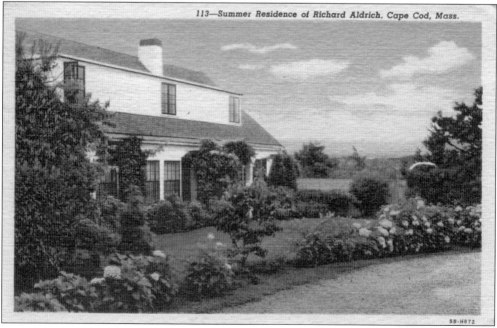

113—Summer Residence of Richard Aldrich, Cape Cod, Mass.

In 1939, the British actress, singer, and dancer Gertrude Lawrence performed in the pre–Broadway run of *Skylark* at the Cape Playhouse in Dennis. She married Richard Aldrich, the playhouse's producer, a year later, and this is a postcard of their home. Lawrence contributed greatly to the community's theatrical life and charities.

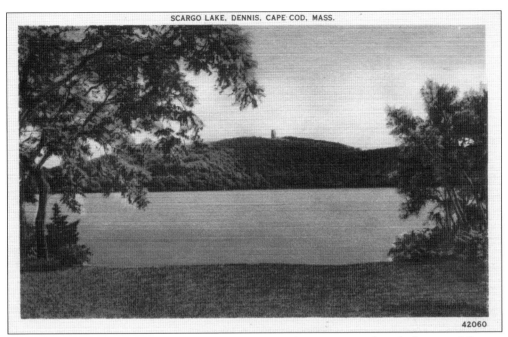

42060

From Brewster, Route 6 enters the town of Dennis and swings around sandy-bottomed Scargo Lake. Visitors can enjoy picnic tables, playgrounds, and two beaches. In addition, the Scargo Tower, built in 1901, is a 30-foot observatory that sits atop the highest hill in the Mid-Cape.

Greetings from Dennis on Cape Cod

A short drive off of Route 6 will lead the tourist to crescent-shaped Corporation Beach. Since it forms a tidal pool at low tide, it is great for exploring and walking. Handicapped-accessible, the bay water is usually warm and calm.

59

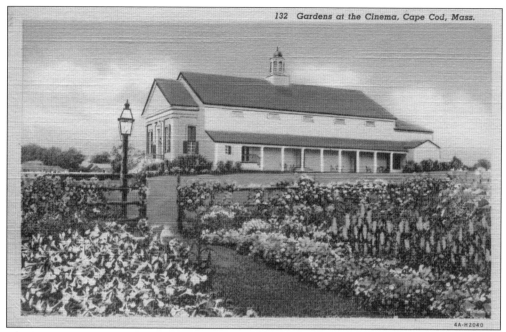

4A-H2040

The Cape Cinema in Dennis opened in 1930 and was designed after the Congregational church in Centerville, Massachusetts. Still in operation today, the cinema features a 6,400-square-foot mural on the auditorium ceiling.

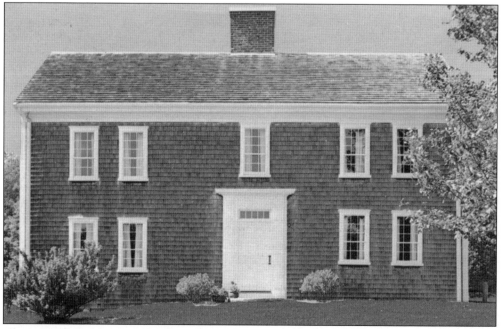

The town of Dennis is named after its first minister, Josiah Dennis. His home, built in 1736, is a museum today and is listed in the National Register of Historic Places. Exhibits include artifacts of early Dennis life, spinning and weaving, and a Dennis maritime wing.

From Dennis, Route 6 enters the town of Yarmouth, which was settled in 1639. Native Americans of the Wampanoag Nation lived on the land and called it Mattacheese. Yarmouth has some beautiful homes with gardens, such as the one pictured above.

A QUAINT BIT OF YARMOUTHPORT, CAPE COD, MASS.

The early settlers of Yarmouth made their living from farming, fishing, and salt evaporation. The town derives its name from an English town located 100 miles north of London. In this postcard, Route 6 passes directly in front of these homes as elm trees line the road.

61

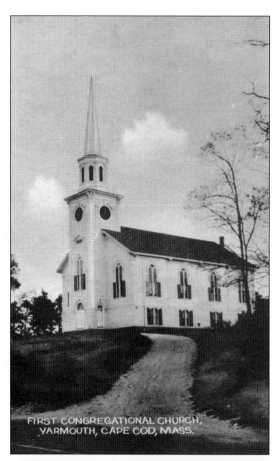

FIRST CONGREGATIONAL CHURCH,
YARMOUTH, CAPE COD, MASS.

The First Congregational Church overlooks Route 6 from atop Zion Hill. Built in 1870, the steeple is 135 feet high and was used as a navigational beacon by ships at sea. The pipe organ used by the choir was built in 1892 and donated by a member of the congregation.

The Thacher Tea House was one of Yarmouth Port's famous landmarks. Serving only lunch and dinner, the establishment had three dining rooms. Named after the glass used on the porches, they were the Lace Porch, Green Porch, and Thousand Island Porch.

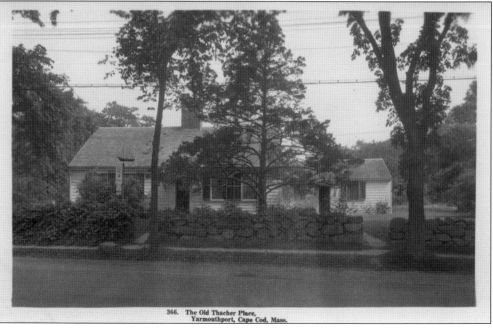

366. The Old Thacher Place,
Yarmouthport, Cape Cod, Mass.

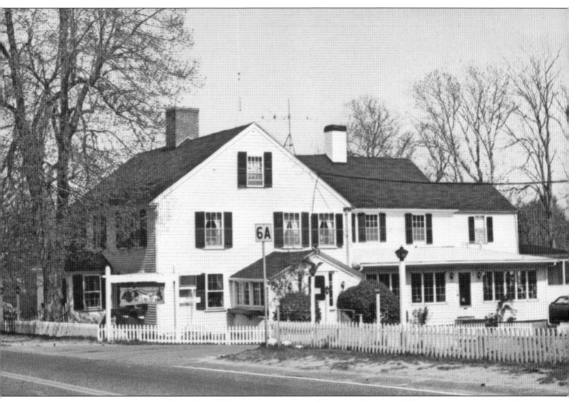

Tracing its beginnings to 1696, the Old Yarmouth Inn claims to be the oldest inn on Cape Cod. Located directly on Route 6, the inn was ideally situated along the main road, and its 1860 guest registry is preserved to this day. According to the inn's website, a few ghosts have been seen, but they are mischievous, not scary.

Traveling down Route 6, one can find another inn, Anthony's Cummaquid Inn. Bought by the famous Anthony Athanas, owner of Anthony's Pier 4 Restaurants, it has been operated by the Athanases since 1975. Although it once offered lodging, the inn is used only as a restaurant today.

Three

Upper Cape

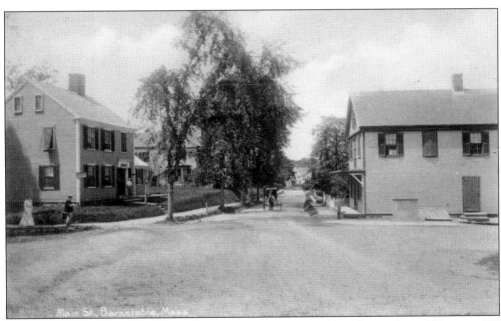

A horse pulling a buggy travels down Main Street in Barnstable. This road would become US Route 6 decades later when the automobile replaced the stagecoach. Families started to settle in Barnstable in the late 1630s, and the town was officially established in 1639.

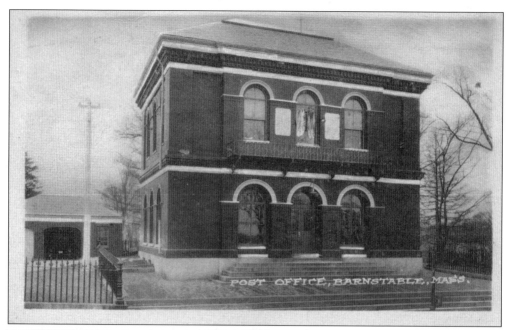

The port of Barnstable was one of the busiest on the Cape, and this building was its customhouse, built in the 1850s. The second floor was used for customs until 1913, and the first floor was a post office until 1958. Today, it is the Coast Guard Heritage Museum, with exhibits detailing the history of the US Coast Guard.

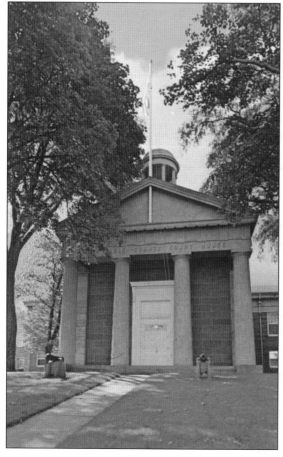

The Barnstable County Courthouse was built between 1831 and 1832. The four Doric columns are made to look like stone, but they are actually made of wood. Built using mainly Quincy granite, it was designed by the famous architect Alexander Parris. In 1981, it was listed in the National Register of Historic Places.

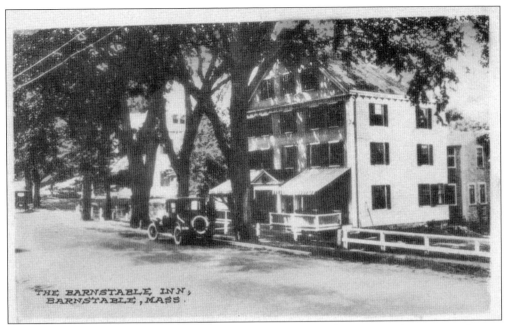

The historic Barnstable Inn was built in the 18th century and was a popular stagecoach stop. In 1971, it caught fire and was completely destroyed. Today, the site is home to the Barnstable Restaurant and Tavern. Owned and operated by a husband and wife team, the restaurant features "Creative Cape Cod/American Cuisine."

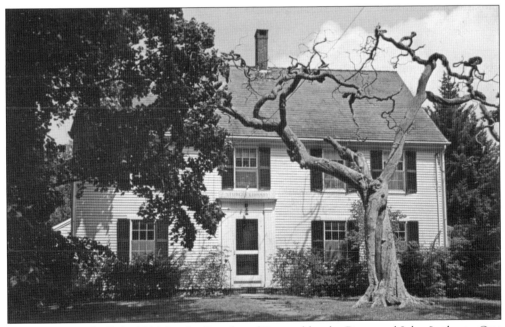

This home was built in 1644 for the founder of Barnstable, the Reverend John Lothrop. One of his descendants, William Sturgis, was born here in 1782. When he was 15 years old, Sturgis went to sea; he eventually became a successful clipper ship owner. He willed his former home for use as a library, and it opened in 1867.

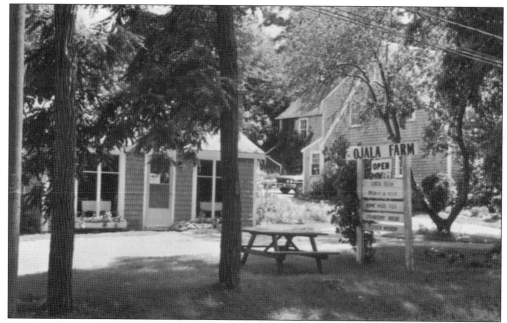

Ojala Farm was a restaurant owned and run by Martha Ojala. She arrived from Finland as a young girl in 1910 and started the restaurant in 1955 after her husband died. The family-style restaurant featured Finnish cuisine as well as lobster bisque and clam chowder. Martha passed away in 1998, and the restaurant is no longer open.

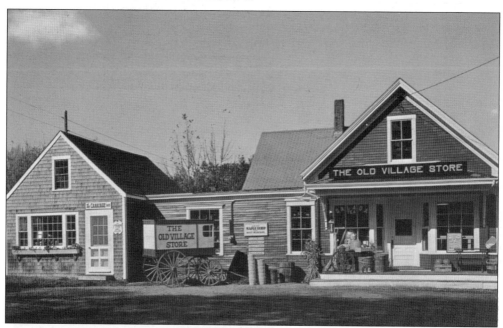

The Old Village Store is located in West Barnstable and first opened in 1881. West Barnstable was the second part of the town to be settled in 1644 after land was purchased from a Native American. The area became mainly agricultural with farmhouses, barns, wide fields, and stone walls.

Leaving Barnstable, Route 6 enters the town of Sandwich. Established in 1637, Sandwich was the first town to be established on the Cape and is named after a town in England. This is a postcard of the Old Colony Motel, which has since closed.

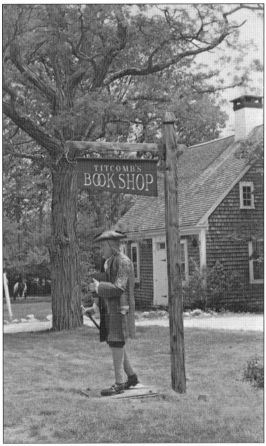

Titcomb's Bookshop is owned and operated by Ralph and Nancy Titcomb and sells both new and used books. In 1974, the famous wrought-iron colonial man statue was placed outside. It was crafted by the Titcombs' eldest son, Ted, as part of his college portfolio. Thirty-five years later, with a new coat of paint every other year, the statue has become a landmark for travelers. The current barn-style building that houses Titcomb's Bookshop was built in 1987 by two of the Titcombs' sons, Paul and Ted. The Titcombs' eldest daughter, Vicky Uminowicz, joined the family business in 1991 and began expanding the store's inventory of new books.

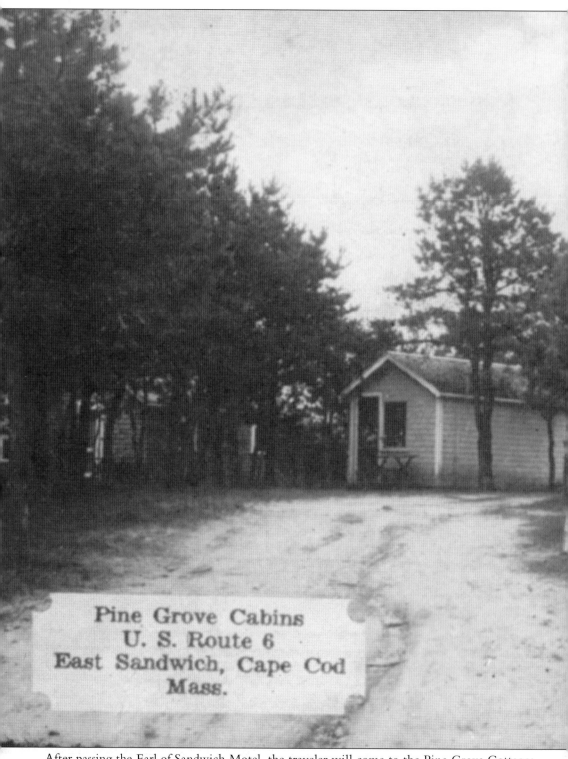

Pine Grove Cabins
U. S. Route 6
East Sandwich, Cape Cod
Mass.

After passing the Earl of Sandwich Motel, the traveler will come to the Pine Grove Cottages. The cottages are furnished; have modern appliances, heat ,and air-conditioning; and linens are

E GROVE
ABINS
NNO WATER
USHES
TYDOL STATION
ROSS ROAD

7299

provided. Guests can relax in the in-ground pool, and children can use the playground.

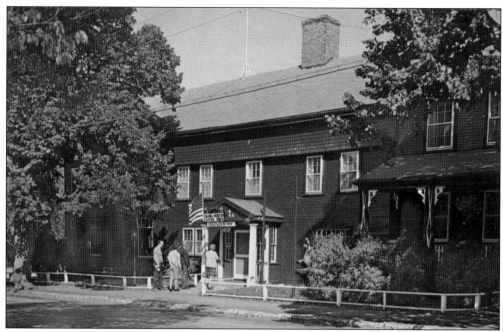

The Daniel Webster Inn was built to be used as a parsonage for the Reverend Rowland Cotton and his wife, Elizabeth Saltonstall, in the early 18th century. Later, it was expanded and operated as the Fessenden Tavern until the 1800s. Daniel Webster, a prominent Boston attorney and US senator, had a room reserved at the inn from 1815 to 1851.

The First Parish Unitarian Church was built in 1833 and was designed by Whittemore Peterson of Duxbury, Massachusetts. The church was sold in 1965, and for many years was the Yesteryears Doll Museum, but it is a private residence today. When the first meetinghouse in Sandwich was built in 1637, it was at this location.

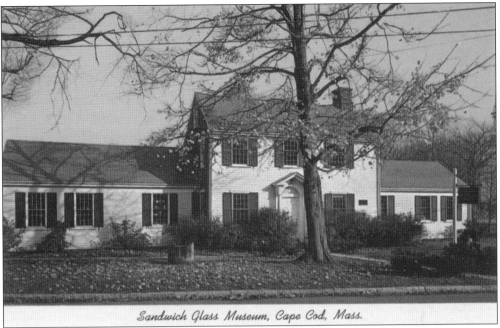

Sandwich Glass Museum, Cape Cod, Mass.

Deming Jarves, a Boston businessman and former glass company agent, founded the Boston & Sandwich Glass Company in 1825. The company was successful and made high-quality products. When the plant closed in 1888, it caused economic hardship in the community. Today, one can learn about the history of glassmaking in the town at the Sandwich Glass Museum.

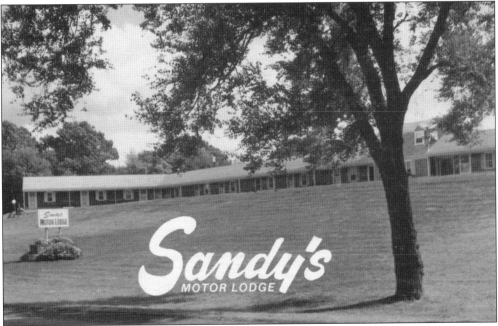

Located on six acres and a half mile north of Sandwich Center was Sandy's Motor Lodge. Today, it is the Sandwich Lodge & Resort and is open all year. With over 70 rooms, guests can enjoy a seasonal outdoor pool, heated indoor pool with Jacuzzi, and complimentary continental breakfast—and some rooms are pet-friendly.

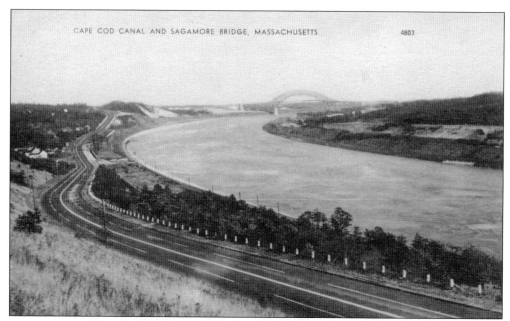

Route 6 enters the town of Bourne before heading over the canal on the Sagamore Bridge. The actual idea of building a canal goes all the way back to Myles Standish of the Pilgrims, when he first suggested it as a way to improve commerce. This postcard shows an excellent view of Route 6 heading west as it runs parallel to the canal in Bourne.

148 STATE HIGHWAY, ALONG THE CAPE COD CANAL, MASS. 90733

Originally part of Sandwich, Bourne became its own town on April 2, 1884. With the only bridges over the canal located within its boundaries, Bourne is known as the gateway to Cape Cod. The canal extends from Sandwich to Buzzards Bay and is eight miles in length. Today, there are places to shop, eat, and watch pleasure boats, fishing boats, container ships, and cruise ships sail by.

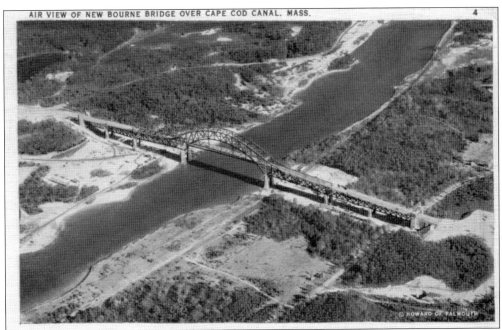

© HOWARD OF FALMOUTH

Route 6 passes underneath the Bourne Bridge as it continues through Bourne. As it does so, it passes Bourne Scenic Park, a family camping area that first opened in 1951 and run by the Bourne Recreational Authority. Visitors can hike, fish, jog, bike, and Rollerblade along the canal. The park also has pools for swimming and a recreation hall with video games and a jukebox.

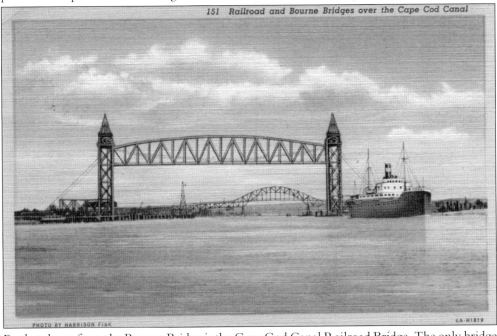

151 Railroad and Bourne Bridges over the Cape Cod Canal

PHOTO BY HARRISON FISK 6A-H1819

Farther down from the Bourne Bridge is the Cape Cod Canal Railroad Bridge. The only bridge by which trains can access the Cape, it is a vertical lift bridge and, at the time of its completion, in 1935, was the longest lift bridge in America. The Cape Cod Central Railroad offers shoreline excursion, brunch, and dinner train rides from May through October.

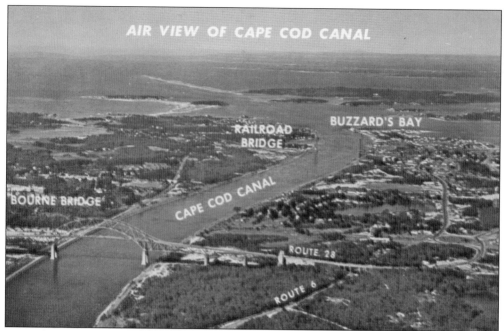

Since 1928, the US Army Corps of Engineers has been responsible for the operations and maintenance of the Cape Cod Canal. Each year, over 14,000 commercial and recreational vessels transit the canal. The swift-running canal current changes direction every six hours and can reach a maximum velocity of 5.2 miles per hour.

The Massachusetts Maritime Academy was founded in Boston in 1891 and moved to Bourne in 1948, after six years in Hyannis. It is the nation's oldest continuously operating maritime academy. Men and women studying at the Massachusetts Maritime Academy train aboard the 540-foot steamship *Kennedy*, named after the late senator Edward M. Kennedy.

Four

WAREHAM AND MARION

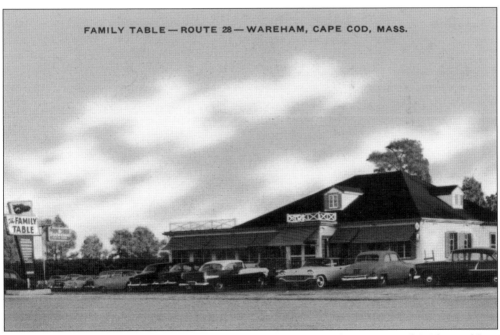

FAMILY TABLE — ROUTE 28 — WAREHAM, CAPE COD, MASS.

Route 6 swings in a northwest direction as it crosses over the Dalton Memorial Bridge and into the town of Wareham. Although settlements had sprung up by the late 17th century, the town was not incorporated until July 10, 1739. The Family Table Restaurant was on Route 6 and Route 28 and specialized in lobsters, seafood, steak, and chicken.

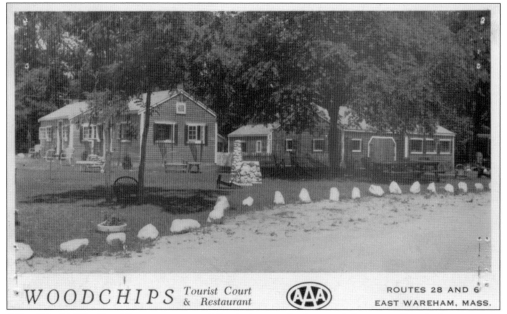

WOODCHIPS *Tourist Court* *& Restaurant* (AAA) ROUTES 28 AND 6
EAST WAREHAM, MASS.

After World War I, with more automobiles being used, the need for upgrading infrastructure, including Route 6, was a major priority. Woodchips Motor Court and Dining room was located at the junction of Route 6 and Route 28 in East Wareham. Guests could rent cottages that were close to beaches and summer theaters.

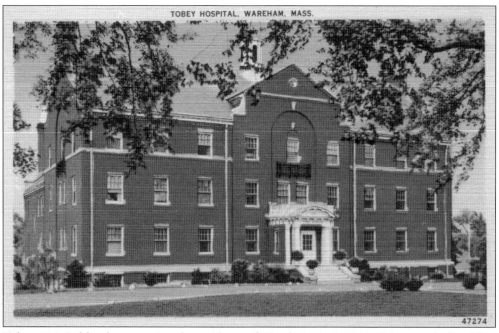

Tobey Hospital has been serving the residents of Wareham since 1940. It is named after Alice Tobey Jones, who donated $250,000 for its initial construction. When it first opened, it contained 40 inpatient beds, a newborn nursery, two operating rooms, X-ray facilities, and a laboratory. Today, it has merged with other local area hospitals as part of the Southcoast Health System.

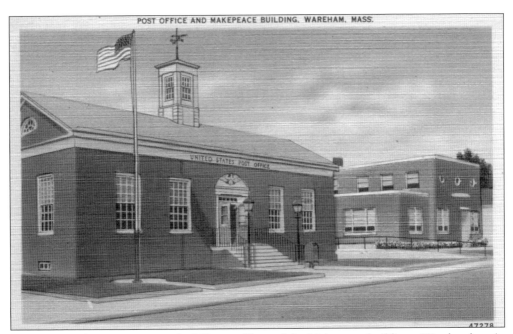

Located directly on Route 6 are the US post office and the Makepeace buildings. Wareham's main industries were fishing, shipbuilding, whaling, and the manufacturing of nails and horseshoes. By the end of the 19th century, the economy of the town would be transformed by new industries, summer tourism, and the growing of cranberries.

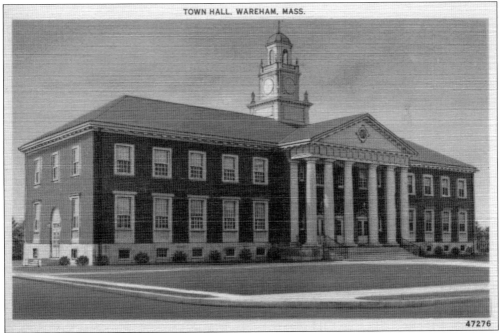

Route 6 follows Main Street parallel to the Wareham River. It then turns left onto Chapel Street and passes by the town hall, which was built in 1938. With the building of the Ocean Spray Cranberry plant, Wareham became a major distribution center for cranberries. While not as important as they once were, cranberries are still an integral part of the town's economy.

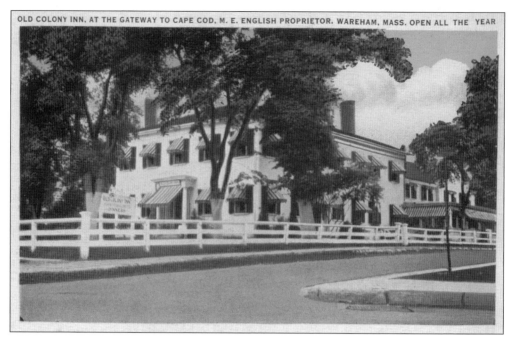

The Old Colony Inn, built in 1825, was a favorite spot for travelers traveling to and from Cape Cod to stop for lunch. When the railroad and local trolley service was established in the town, Wareham saw an increase in tourism. By the late 1800s, the population of the town continued to grow, and a number of immigrants arrived, with the majority from Ireland.

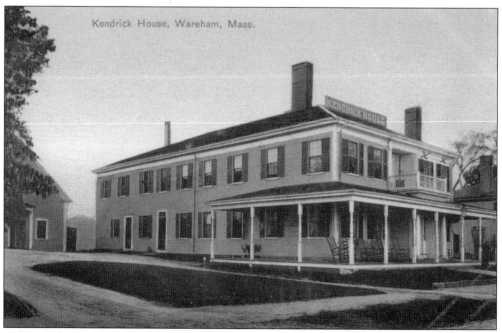

Kendrick House, Wareham, Mass.

Down the street from Tobey Hospital is the Church of the Good Shepard Episcopal Church and the Kendrick House (pictured). Built in 1800, it was a hotel; today, it is now a home for disabled veterans.

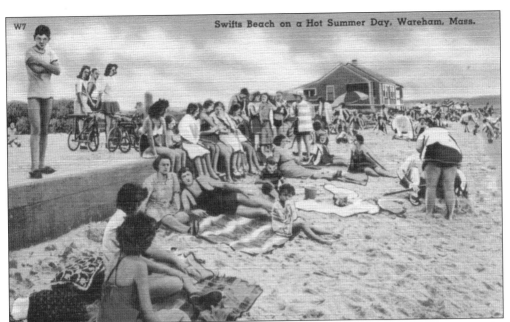

Route 6, known as "the Cranberry Highway," was a major retail corridor in the 1950s, as the increase of automobile traffic to and from the Cape had no other choice but to travel on Route 6. Veering off Route 6 onto Swifts Beach Road, one stays on all the way to the end, which is Swifts Beach. Besides Swifts, the town has seven other beaches for use as well.

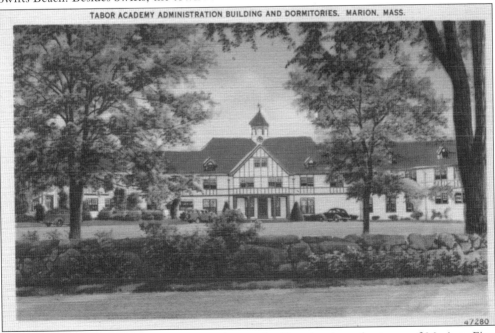

TABOR ACADEMY ADMINISTRATION BUILDING AND DORMITORIES, MARION, MASS.

From Wareham, Route 6 heads in a southwesterly direction into the town of Marion. First settled in 1679, Marion officially became a town in 1852 and was named after Revolutionary War hero Francis Marion. This is a postcard of Tabor Academy, which was founded in 1876 by the widow Elizabeth Taber. It was named in honor of Mount Tabor in Israel; the elite private school has since expanded.

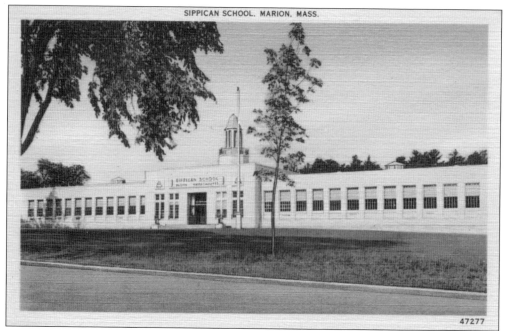

47277

A short drive from Tabor Academy lies the Sippican Elementary School. Sippican was the name of the local Native Americans in the area and archaeologists have determined that the Marion area was settled by indigenous people as far back as 3000 BC. When colonists first settled the area, they called it Sippican.

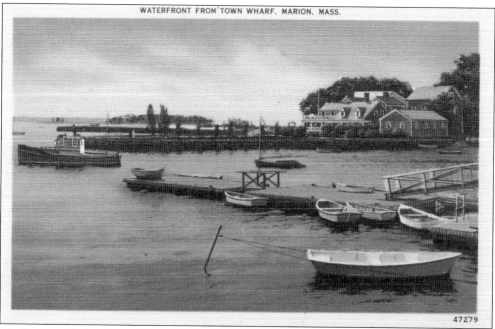

47279

Marion provided sailors for ships engaged in fishing, whaling, and the transporting of cargo all over the world. Boys as young as 16 would join the crews, and some worked their way up to captain ships of their own. This is a postcard of the Beverly Yacht Club; founded in 1872, it is one of the oldest in the country.

Five

MATTAPOISETT
AND FAIRHAVEN

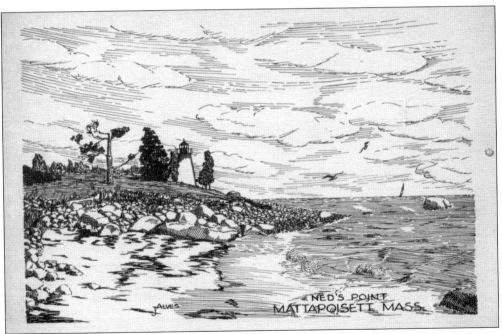

Ned's Point Lighthouse is located in Veterans Memorial Park. It is named after the previous owner of the land, Edwin "Ned" Dexter, and was built in 1838. The Coast Guard automated the light in 1923 and then decommissioned it decades later in 1953. The lighthouse still stands today as an important reminder of Mattapoisett's history with the sea.

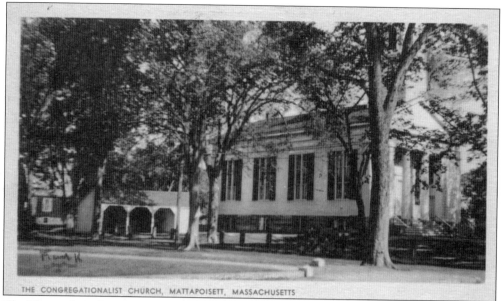

THE CONGREGATIONALIST CHURCH, MATTAPOISETT, MASSACHUSETTS

The Mattapoisett Congregational Church traces its history all the way back to 1736, when nine men and seven women separated from the First Congregational Church of Rochester. Although the community of faith worshipped in earlier meetinghouses, the church in this postcard was designed and built by architect and church deacon Solomon K. Eaton in 1842.

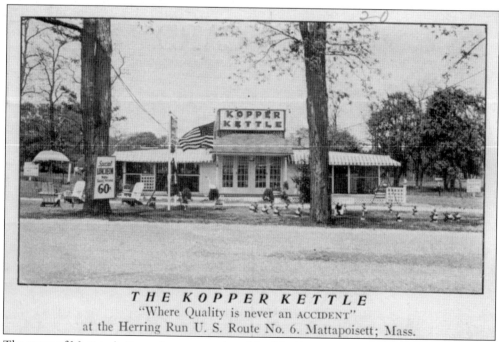

THE KOPPER KETTLE
"Where Quality is never an ACCIDENT"
at the Herring Run U. S. Route No. 6, Mattapoisett; Mass.

The town of Mattapoisett was incorporated on May 20, 1857, as it had been previously a village within the town of Rochester. Its main economy was centered on building ships for fishing, whaling, and trading. Located directly on Route 6, the Kopper Kettle Restaurant served many hungry travelers.

84

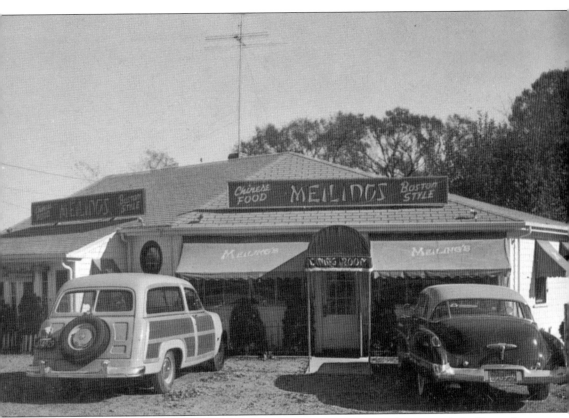

In 1950, husband and wife, George and L. Meiling Yen brought the Chinese-style buffet to the area when they opened their restaurant Meiling's on Route 6. L. Meiling arrived in the United States when she was seven years old and first settled in Attleboro, Massachusetts. Meiling's was a very popular restaurant and closed in 1979.

HILLSIDE MOTEL - ROUTE 6 - MATTAPOISETT, MASS.

Mattapoisett was first inhabited by Wampanoags who made their villages along the future harbors of the town during the summer. The name *Mattapoisett* is a Wampanoag term referring to the scenic harbor, and its meaning is interpreted as "place of rest." The town would become famous for building hundreds of ships specifically for the whaling industry.

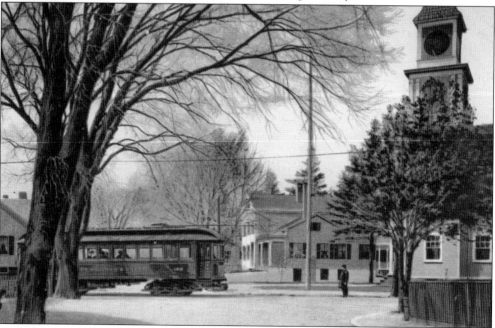

In this postcard, a trolley travels right in front of Mattapoisett Town Hall. Right next to town hall is the Mattapoisett Museum and Carriage House where visitors can learn about the rich history of the town through exhibits and special programs. From Mattapoisett, Route 6 enters the town of Fairhaven, which was first settled in 1653. A group of colonists from the Plymouth Colony bought the land from Chief Massasoit of the Wampanoag.

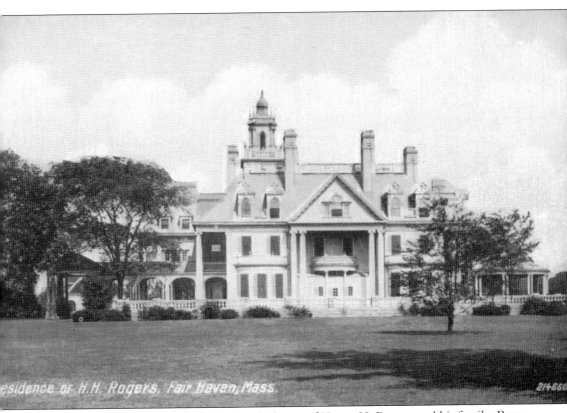

esidence of H.H. Rogers, Fair Haven, Mass. 214560

This 85-room mansion on Fort Street was the home of Henry H. Rogers and his family. Born in Fairhaven in 1840, Rogers worked a few jobs, including as a brakeman for the Old Colony Railroad, before entering the oil business in the 1860s. He eventually became a multimillionaire with the Standard Oil Company.

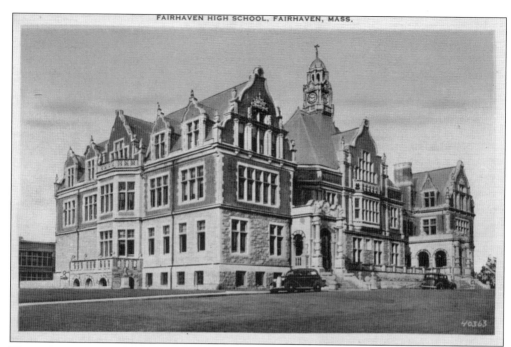

Henry Rogers would not forget his hometown, as between 1885 and 1906, he would provide the capital for numerous projects and buildings such as Fairhaven High School, which was built in 1904. In 1965, the town moved the Henry H. Rogers Monument to the school grounds.

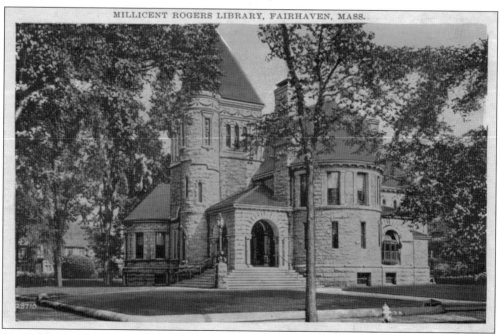

MILLICENT ROGERS LIBRARY, FAIRHAVEN, MASS.

The Millicent Library, another gift from Rogers, opened in 1893. The library is named after one of Rogers's daughters, Millicent, who died at age 17 in 1890. Since she loved to sketch and read, building a library was a fitting way to memorialize her. One of the collections held by the library is that of Mark Twain's manuscripts and letters.

88

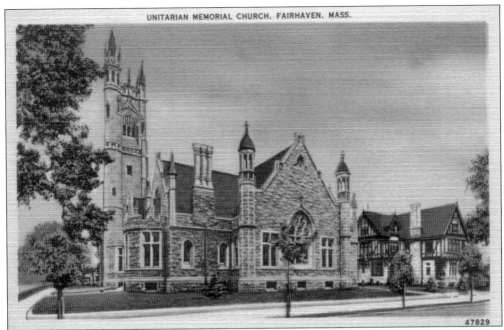

47829

The Unitarian Memorial Church was a gift to Fairhaven in honor of his mother, Mary Eldredge Huttleston Rogers. When the church was dedicated on October 4, 1904, Mark Twain, a close friend of Rogers's, was one of the speakers. The bell tower is 165 feet high and supports 11 bells that weigh a combined 14,000 pounds.

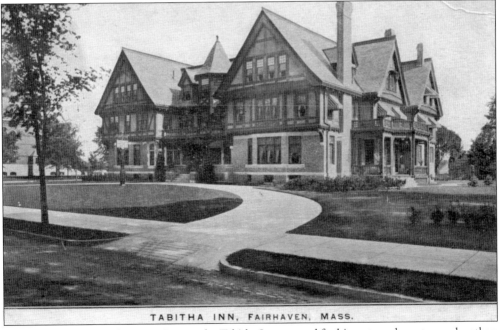

TABITHA INN, FAIRHAVEN, MASS.

Another gift of Rogers's generosity was the Tabitha Inn, named for his maternal great-grandmother. When it opened in 1905, it was a first-class resort hotel until 1942, when it was used to house Coast Guard trainees. Today, it is called Our Lady's Haven and is owned by the Fall River Diocese of the Catholic Church.

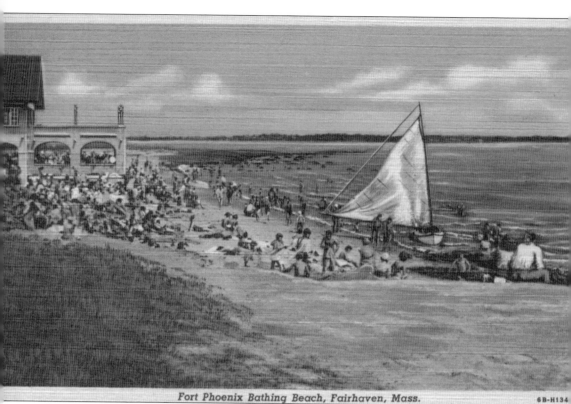

Fort Phoenix Bathing Beach, Fairhaven, Mass.

6B-H134

One of Fairhaven's historic sites is Fort Phoenix, built during the American Revolution in 1777. Positioned at the entrance to the Acushnet River, it was supposed to protect the harbors of both Fairhaven and New Bedford from British attack. When the Royal Navy arrived in 1778, the fort was not much of a deterrent, as both suffered considerable damage.

Six

NEW BEDFORD

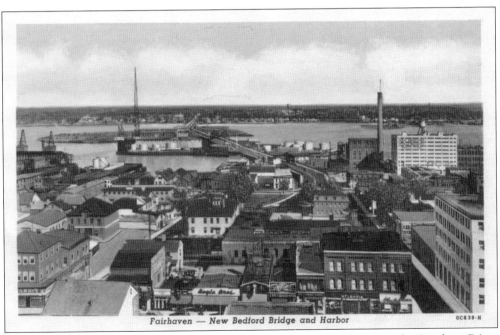

Fairhaven — New Bedford Bridge and Harbor

This postcard shows an excellent view from New Bedford looking east over the Acushnet River into Fairhaven. Route 6 travels over a few bridges as it makes it way from Fairhaven, first crossing over Popes Island, then on a swing bridge connecting Popes Island and Fish Island, and finally entering New Bedford.

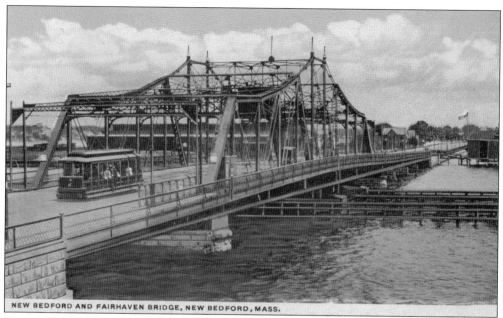

NEW BEDFORD AND FAIRHAVEN BRIDGE, NEW BEDFORD, MASS.

The first bridge to connect the two communities was built in 1801. Over the years, the bridge was either damaged or completely destroyed by storms. The bridge seen in this postcard image was built in 1902 and has a hydraulic draw that swings the bridge so that ships can pass through. This bridge, built at a cost of $1.4 million, stills carries Route 6 between Fish and Pope Islands.

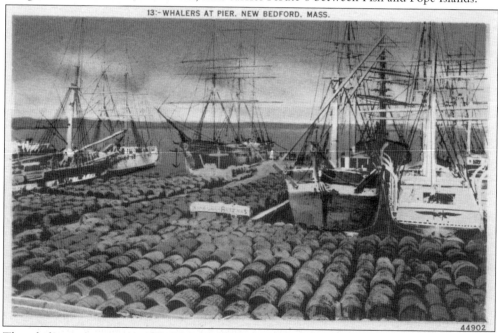

13:-WHALERS AT PIER. NEW BEDFORD, MASS.

The whaling industry took off in New Bedford with the arrival of Joseph Rotch from Nantucket in 1765. With Rotch's vast knowledge of whaling and capital, and his enthusiasm to bring others into the business, New Bedford eclipsed Nantucket as the leading whaling port by 1830. In 1857, just before the decline of whaling, the city had over 300 whalers, and the industry was valued at over $12 million.

Today, the history of whaling and New Bedford's rich connection to it is preserved at the New Bedford Whaling Museum. This is a postcard of one of the exhibits housed in the museum, the *Lagoda*, a half-scale replica of a square-rigged whaler. In 1916, the model was donated by Emily Howland Bourne in honor of her father, Jonathan Bourne. He was one of the most successful whaling merchants in New England.

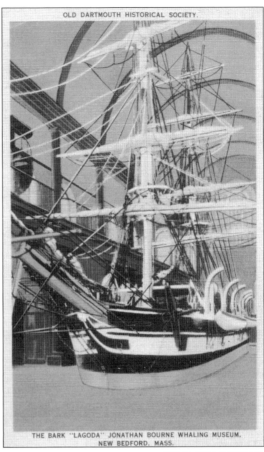

OLD DARTMOUTH HISTORICAL SOCIETY.

THE BARK "LAGODA" JONATHAN BOURNE WHALING MUSEUM, NEW BEDFORD, MASS.

With the discovery of oil in Pennsylvania and the beginning of the Civil War in 1861, New Bedford's prosperous whaling days came to an end. However, commercial fishing and the shipping of cargo still make the port of New Bedford an active one today. Also on State Pier is a passenger ferry terminal that services both Martha's Vineyard and Cuttyhunk Island.

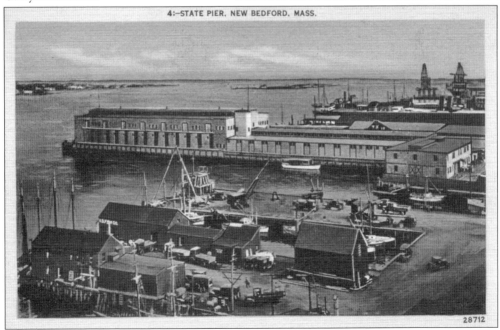

4:-STATE PIER, NEW BEDFORD, MASS.

28712

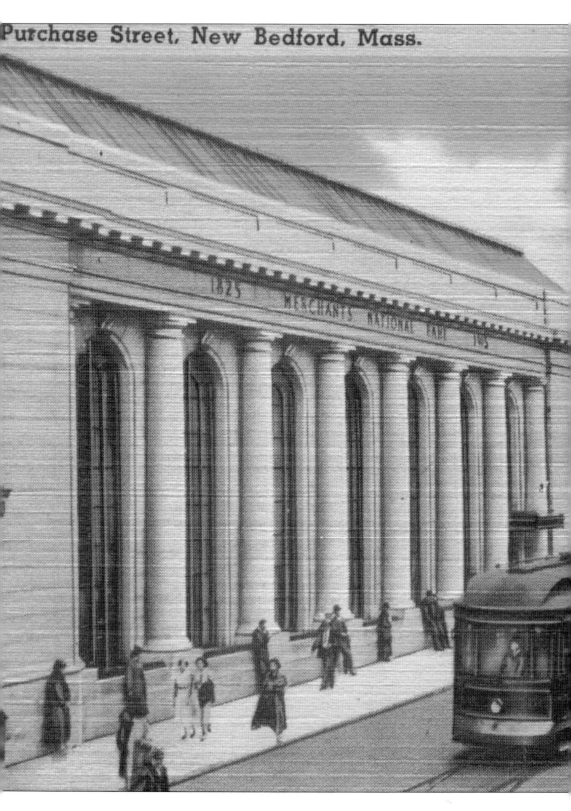

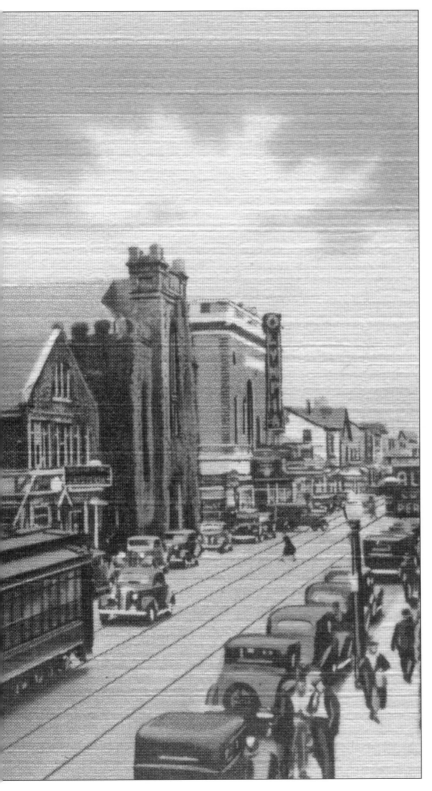

The building next to the church in this postcard is the Olympia Theatre, which opened on April 2, 1916. In 1962, the Zeitz family purchased the theater, and a national touring company performed the comedy *Barefoot in the Park* in 1966. After the theater closed in 1971, it was demolished a year later.

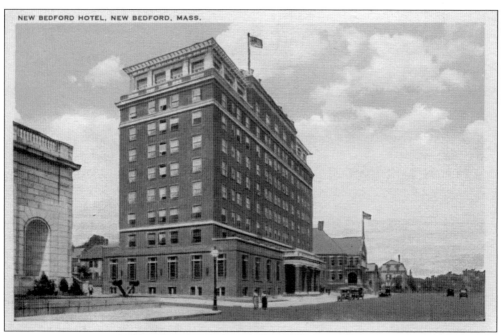

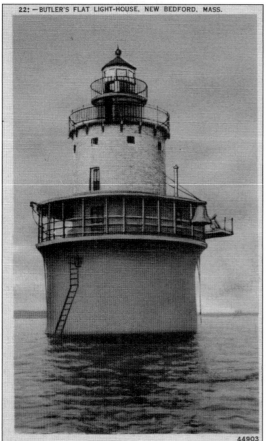

22: — BUTLER'S FLAT LIGHT-HOUSE, NEW BEDFORD, MASS.

44903

Tourism is one of the major industries of New Bedford today as the National Park Service established New Bedford Whaling National Historical Park in 1996. Many historic buildings from earlier days still stand, such as the New Bedford Hotel. Although the hotel closed in 1958, the structure is used as senior housing today.

The destruction caused to New Bedford and Fairhaven by the hurricanes of 1938 and 1954 led to the building of a hurricane barrier in 1966 that protects ports. Just outside the hurricane barrier lies the Butler Flats Lighthouse. Replacing Clark's Point Light, it was built in 1898 at the cost of $34,000. The best views of the lighthouse from land can be seen from Fort Rodman in New Bedford.

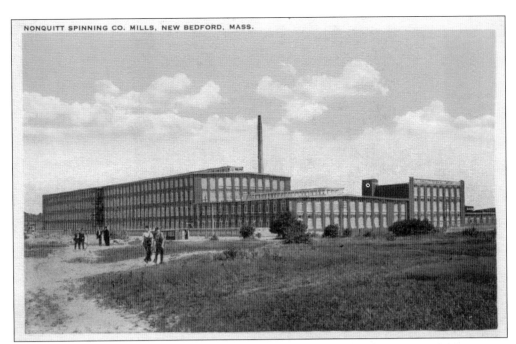

NONQUITT SPINNING CO. MILLS, NEW BEDFORD, MASS.

Besides whaling and commercial fishing, mills and factories were a way of life in New Bedford. Wamsutta Mills opened first in 1849, and its shirting became the first of many world-famous Wamsutta products. By the late 1800s, more than 50 mills were in operation, but trouble was on the horizon, as numerous factors led to the closing of most by the 1930s.

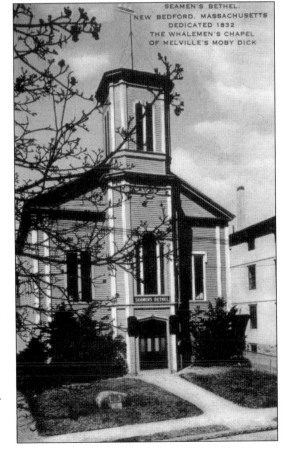

SEAMEN'S BETHEL,
NEW BEDFORD, MASSACHUSETTS
DEDICATED 1832
THE WHALEMEN'S CHAPEL
OF MELVILLE'S MOBY DICK

The Seaman's Bethel has been a house of worship for captains and sailors from all over the world since 1832. It is a product of an organization called the New Bedford Port Society, which was created in 1830 to improve the morals of seaman. The pulpit facing the worshippers looks like the bow of a ship, and the cushions on the pews are made of sail canvas.

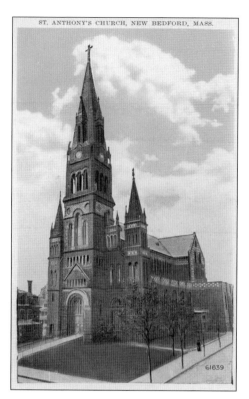

ST. ANTHONY'S CHURCH, NEW BEDFORD, MASS.

61839

Some of the first settlers in what would become the city of New Bedford were Quakers and Baptists who were trying to find relief from religious persecution. Many would follow, such as the future social reformer, abolitionist, orator, writer, and statesman Frederick Douglass, who arrived in 1838, soon after escaping slavery in Maryland. The city would be comprised of numerous ethnic groups who would practice their religious beliefs in churches throughout the city, such as St. Anthony's.

THE WHALEMAN, BY BELA PRATT, NEW BEDFORD, MASS.

In 1910, the New Bedford Public Library moved from the second floor of city hall across the street to its present location. The library has an extensive genealogy department and a special Melville Whaling Room that contains excellent writings on the history of whaling. To the right of the entrance is a memorial to the whaling industry with an inscription that reads, "A dead whale or a stove boat."

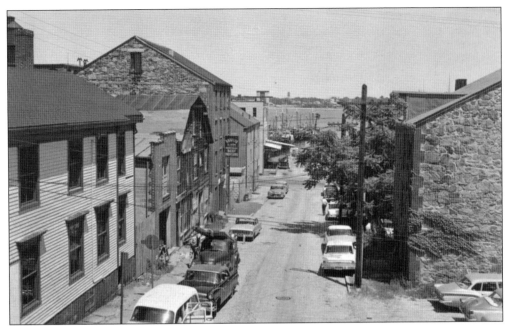

This is a view on Center Street looking east to the waterfront. When the British attacked in 1778, this area was completely destroyed. The Caleb Spooner House, built in 1806, was moved here to save it from destruction. Three generations of sparmakers lived in the house next door: the Henry Beetle House.

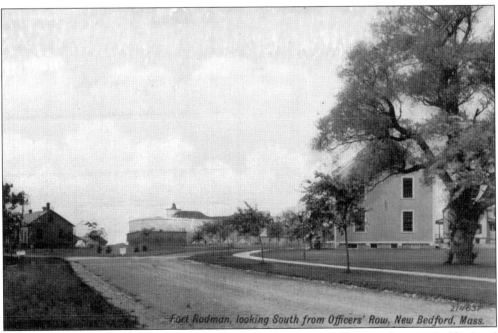

Fort Rodman, looking South from Officers' Row, New Bedford, Mass.

Named after the mayor of the time, Fort Taber was built to protect both New Bedford and Fairhaven during the Civil War. In 1898, the name of the fort was changed to Rodman in honor of New Bedford native Lt. Col. William Logan Rodman, who was killed at Port Hudson, Louisiana, during the Civil War. In the 1970s, the fort was sold to the City of New Bedford.

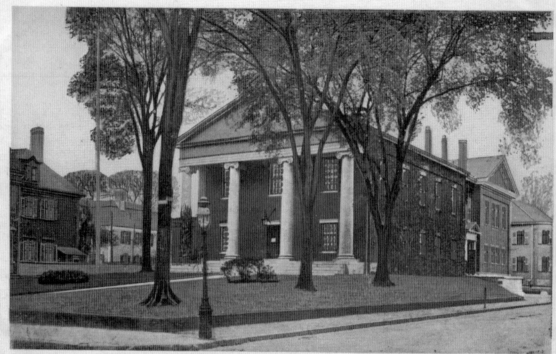

Bristol County Court House where Lizzie Bordon was tried, New Bedford, Mass.

One of the most sensational crime dramas of the late 19th century was the case of Lizzie Borden, who was arrested and charged with the brutal murder of her parents with an axe. The trial was held in 1892 at the Superior Court House on Court and County Streets. The jury found Borden not guilty, and the question of her innocence is still hotly debated today.

Seven

DARTMOUTH AND
WESTPORT

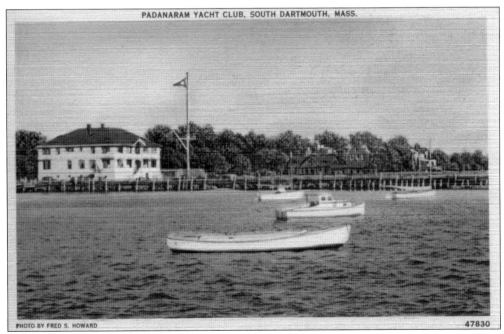

PADANARAM YACHT CLUB, SOUTH DARTMOUTH, MASS.

PHOTO BY FRED S. HOWARD 47830

Land was sold to Plymouth colonists by Massasoit and his eldest son, Wamsutta, in 1652 and the town of Dartmouth was incorporated in 1664. Padanaram is a village in the southern part and lies along the Apponagansett River. During the middle of the 18th century, the area became a major shipbuilding center.

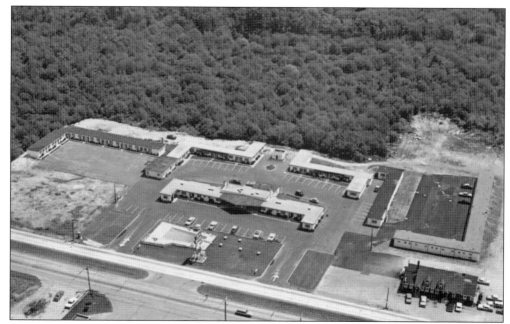

Traveling west on Route 6 is mostly without any abrupt direction changes, and one of the most long-standing hotels on it is the Capri. Dartmouth is home to a satellite campus of the University of Massachusetts and was famous for its amusement park, Lincoln Park, for decades.

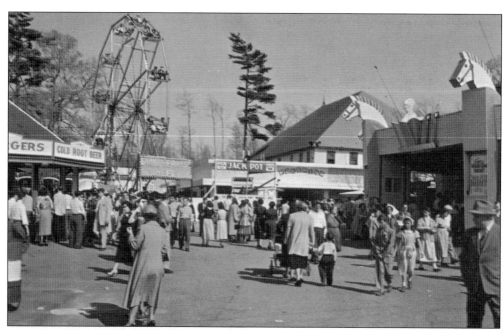

On July 4, 1894, Lincoln Park officially opened on a modest 20 acres of land. Eventually deriving its name from a contest, the park continued to grow as a giant coaster was added in 1912. A new dance hall opened in 1921, and a carousel was installed that would continue to operate until 1985.

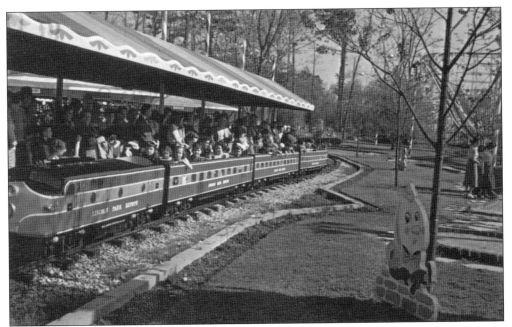

In 1941, Boston investors purchased the park, and in the latter part of the decade, a new coaster, the Comet, was built. The park expanded to over 40 acres as a bowling alley was built, the dance hall was upgraded, and more concessions stands and games were added.

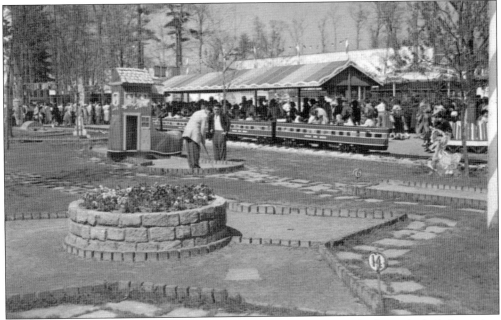

New owners took over in the 1980s, and for the first time, the park charged admission prices to enter. Even favorite rides had to be auctioned off, including the famous carousel. Luckily, it found new life at Battleship Cove in Fall River, Massachusetts. Unfortunately, due to economic reasons, the park officially closed in 1987.

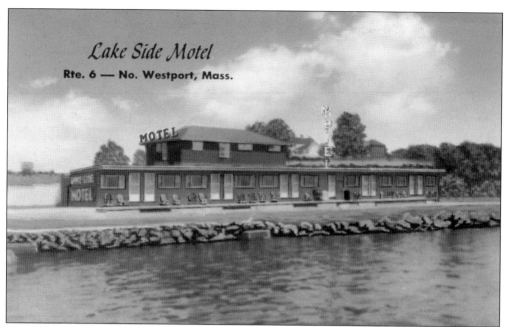

Lake Side Motel
Rte. 6 — No. Westport, Mass.

Route 6 skirts by the southern portion of Noquochoke Lake and heads in a northwesterly direction as it enters the residential town of Westport. The town, first settled in 1670, derives its name because it was the westernmost port in the Massachusetts Bay Colony. As in most coastal towns that Route 6 travels through, whaling was one of its most important industries.

Town Hall, Westport, Mass.

Westport was incorporated as a town in 1787, and one of its most prominent citizens was Paul Cuffe. Born in 1759, he was a Native American/African American Quaker businessman, sea captain, patriot, and shipbuilder. For his day, he was one of the richest African Americans and began the first integrated school in the United States before his death in 1817.

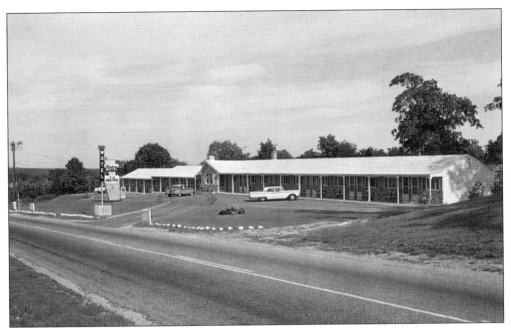

Several mills were built along various streams and rivers, including the Westport River. The biggest mill was located where the Westport River meets Lake Noquochoke as Route 6 crosses into Westport from Dartmouth. At the turnoff from Route 6 onto Route 177 was the 20-room Chateau Motel.

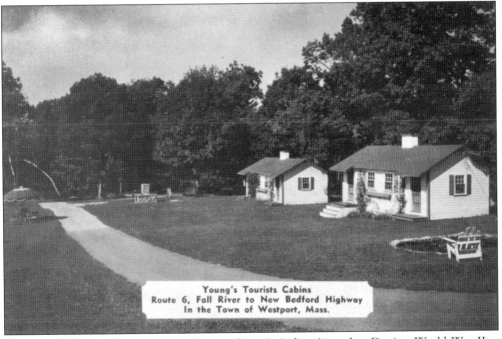

Young's Tourists Cabins
Route 6, Fall River to New Bedford Highway
In the Town of Westport, Mass.

Tourism, fishing, and farming are the town's main industries today. During World War II, a coastal defense was built on Gooseberry Island to protect the town from German attack, and during the summer months, residents and tourist alike flock to nearby Horseneck Beach. Located along Route 6, Young's Tourist Cabins were very popular.

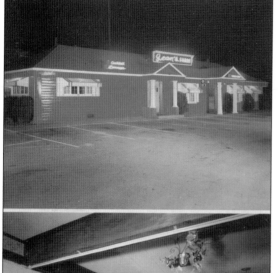

The Macomber turnip was created by brothers Adin and Elihu Macomber in 1876 when they used cross-pollination to produce a creamy white turnip that has a sweet taste with a touch of bitterness. They are still grown on local farms today and are a staple during the fall and winter. One of the most popular restaurants on Route 6 was Jean's Farms Steak House.

An excellent view shows Route 6 as it passes in front of White's of Westport Restaurant before entering the city of Fall River. White's was started by the husband and wife team of Roland, who went by "Aime," and Rita Lafrance on Easter Sunday in 1955. Earning a reputation for uncompromising excellence, White's is a longtime favorite choice for fine dining, wedding receptions, banquets, functions, and meetings to this day.

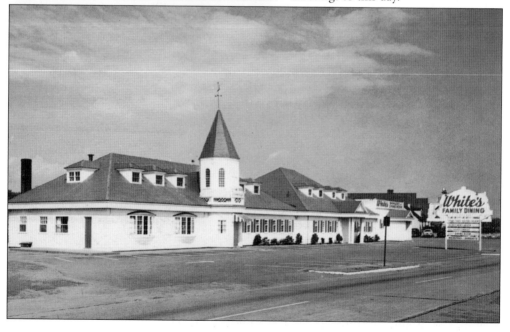

Eight

FALL RIVER

Watuppa Lake, Fall River, Mass.

From Westport, Route 6 travels between Watuppa Lake to the North and Watuppa Pond to the South and into the historic city of Fall River. It passes right in front of LePage's Seafood and Grille, which first opened in 1989. Fall River began to be settled by the late 1600s, and its main industry was farming. (Courtesy of Fall River Public Library.)

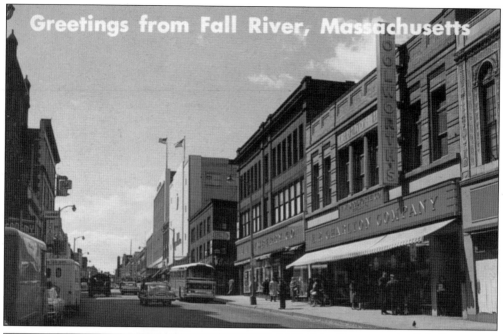

Greetings from Fall River, Massachusetts

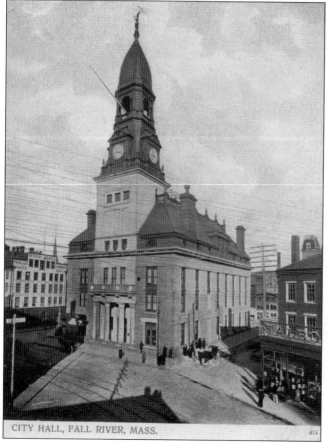

CITY HALL, FALL RIVER, MASS.

Known as the Spindle City, Fall River was once the leading textile city in the United States. The city was a major factor in the origins and success of the Industrial Revolution. From docks on the Taunton River, steamships served New York, Philadelphia, and Providence. Although many textile mills closed or moved south by the 1940s, the New York City garment industry established a base in the city, and an economic resurgence soon followed. (Courtesy of Fall River Public Library.)

This image offers an excellent view of Fall River City Hall. The first mayor was Jason Buffington. In the early 1960s, city hall was demolished, and a new one was built directly over the new Interstate 195. (Courtesy of Fall River Public Library.)

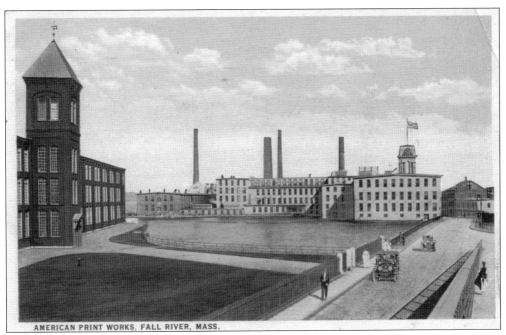

AMERICAN PRINT WORKS, FALL RIVER, MASS.

American Print Works began operations in January 1835 with four printing machines and was, at one time, the largest printing company in the United States. In the early 1900s, American Print Works had an extensive and ever-increasing export trade. (Courtesy of Fall River Public Library.)

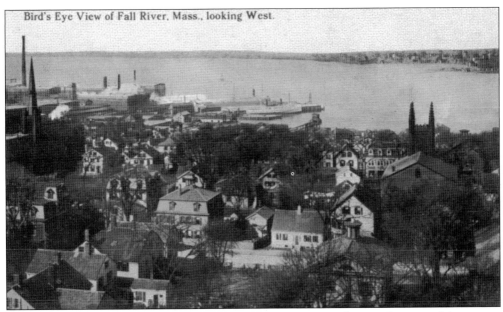

Bird's Eye View of Fall River, Mass., looking West.

The Wampanoags named the area "Quequechan" for the small river that turned into steep falls before flowing into the Taunton River. Since the name *Quequechan* translates into "falling water," the city would be become Fall River. The community was first incorporated as a town in the early 1800s and became a city in 1854 with the motto "We'll Try." (Courtesy of Fall River Public Library.)

In this house on August 4, 1892, Andrew Borden, a prosperous businessman, and his second wife, Abby, were found murdered. A week later, Andrew's youngest daughter, Lizzie, was arrested and charged with killing both. At a time when female murderers were unheard of, the murders and subsequent trial were a media sensation. Lizzie was found not guilty, and no one else was ever charged in connection with the crime. Today, visitors can tour the house, which is now a bed-and-breakfast. (Courtesy of Fall River Public Library.)

The Fall River Historical Society was first organized in 1921, and its museum opened in 1931. This structure is built from Fall River granite and was originally located on Columbia Street in 1843. In 1870, it was moved, stone by stone, to Rock Street, where it was also enlarged and the interior was rebuilt. The museum has extensive exhibits on Fall River's manufacturing history, its Fall River Line of steamships, and the Lizzie Borden murders. (Courtesy of Fall River Public Library.)

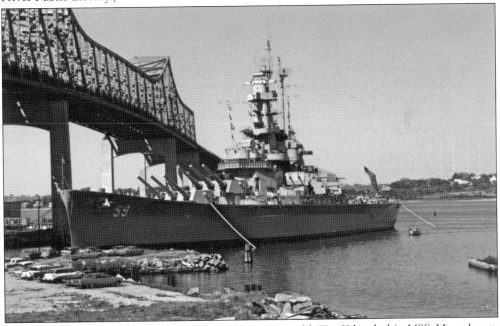

In the early 1960s, the former crew members of the World War II battleship USS *Massachusetts* saved her from destruction and brought her home to serve as the official war memorial for the state. She first opened as a museum in 1965, and today, Battleship Cove is the largest collection of historic naval ships in the world. Visitors can also tour the USS *Joseph P. Kennedy, Jr.* (DD-850) and the USS *Lionfish* (SS-298). (Courtesy of Fall River Public Library.)

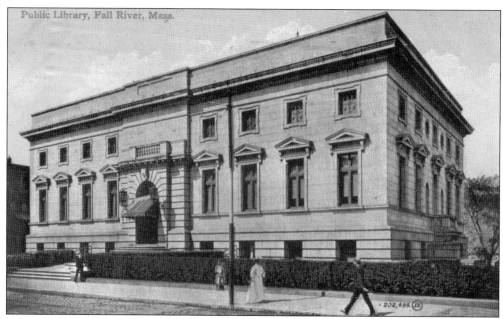

The Fall River Public Library was established in 1861 and first located in city hall until 1886, when a fire destroyed part of the collection. The remaining collection was moved to another building, but it was determined that it would not be a long-term solution, so the city approved the construction of a new one in 1895. Opening in 1899, the library still serves city residents today. (Courtesy of Fall River Public Library.)

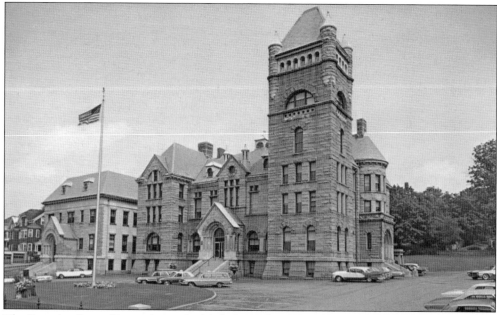

The Superior Court House sits on the birthplace of Col. Joseph Durfee, the home of Micah H. Ruggles and later the residence of Col. Richard Borden. The cornerstone was laid on August 8, 1899, and it was completed in the early 1890s at a cost of $225,000. The Fall River District Registry of Deeds was located here until it moved to a new building in 1931. (Courtesy of Fall River Public Library.)

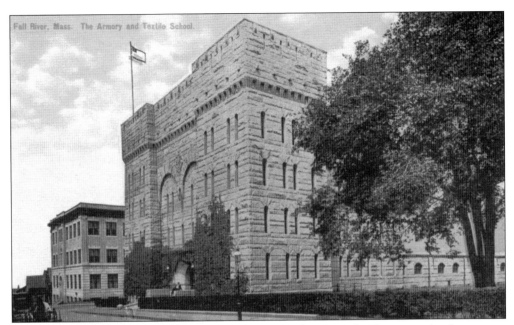

The State Armory was completed in 1897 and contained quarters for six companies. It was soon put to use when war was declared with Spain on April 25, 1898; men reported to the armory and were soon assembled, armed, and equipped. During the war, Battery M of the First Regiment and members of the Naval Brigade were employed in the service of the United States. (Courtesy of Fall River Public Library.)

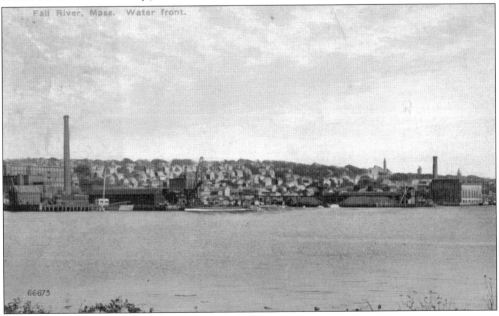

This postcard shows the bustling port of Fall River from the banks of the Taunton River in Somerset. At first, sailing ships carried goods between Fall River, Taunton, and Providence, Rhode Island. In addition, passenger ferries sailed to Providence and, by 1828, had switched to steam power. The first passenger service to New York started in 1845, and between 1840 and 1860, close to a dozen whaleboats sailed from Fall River. (Courtesy of Fall River Public Library.)

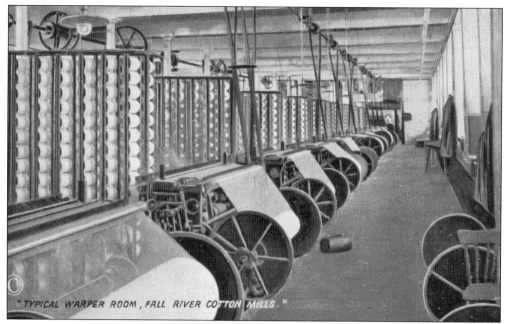

"TYPICAL WARPER ROOM, FALL RIVER COTTON MILLS."

By the early 1900s, Fall River was the largest cotton manufacturing center in the United States and had over 100 mills. With over 400,000 spindles in operation, it soon earned the nickname "Spindle City." In 1911, the city hosted the Cotton Centennial, a weeklong celebration of the city's textile industry. The highlight was the attendance of Pres. William Howard Taft. (Courtesy of Fall River Public Library.)

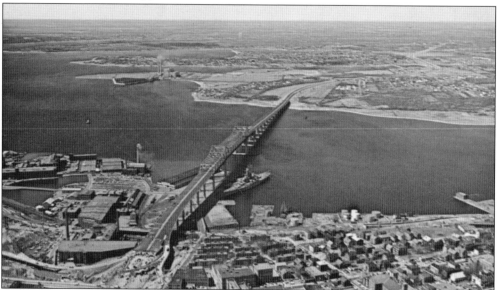

In 1966, the Charles M. Braga Jr. Memorial Bridge opened, and it carries Interstate 195 over the Taunton River from Fall River to Somerset. The 5,780-foot through truss bridge is named after a son of Fall River killed during the attack on Pearl Harbor while serving aboard the battleship *Pennsylvania*. On April 11, 1966, the bridge opened to a one-time pedestrian walk, and the next day, the *Fall River Herald News* reported that an estimated 10,000 to 20,000 people walked across the bridge. (Courtesy of Fall River Public Library.)

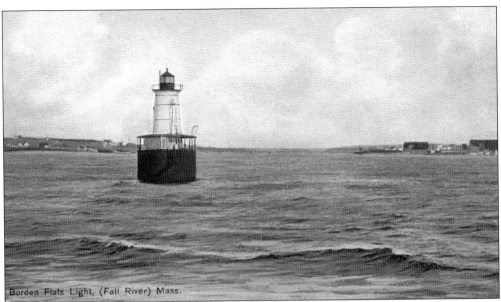

Borden Flats Light, (Fall River) Mass.

The Borden Flats Lighthouse stands just outside the Braga Bridge and protects mariners using Mount Hope Bay. At first, a floating day marker was used to warn mariners of the large underwater reef at the mouth of the Taunton River. However, since no protection was provided at night, the lighthouse became operational on October, 1 1881. Until the Coast Guard took control of the lighthouse in 1939, the US Lighthouse Service provided keepers for the light. To save money, the lighthouse was fully automated in 1963. (Courtesy of Fall River Public Library.)

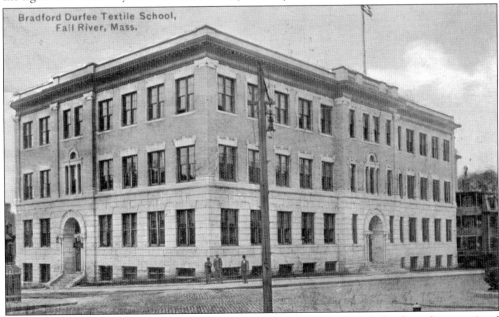

Bradford Durfee Textile School, Fall River, Mass.

The Bradford Durfee Textile School opened on March 7, 1904, and the first class consisted of 164 students. Almost 10 years later, it had 50 day students and 900 evening pupils. It was equipped with modern machinery and laboratories. It catered to those who wished to learn the art of manufacturing before being employed at a mill or those who were already working at a mill but needed specialized training. (Courtesy of Fall River Public Library.)

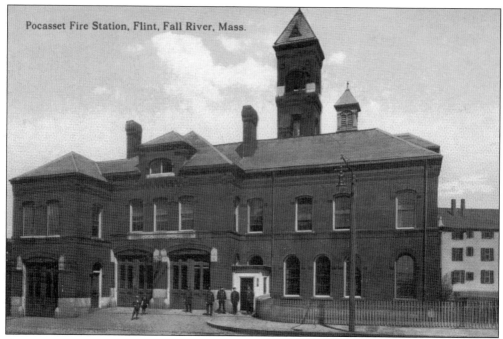

Pocasset Fire Station, Flint, Fall River, Mass.

The city began its fire department when it appointed 10 fire wardens in 1827, and in 1829 an engine was purchased and a firehouse was built. On July 2, 1843, a fire was started by small boys, and it soon engulfed neighboring buildings. Strong winds helped spread the fire, and in total, nearly 200 buildings were destroyed before it was finally extinguished. The city suffered another devastating fire in 1928; this was an additional factor in the decline of the manufacturing industry. (Courtesy of Fall River Public Library.)

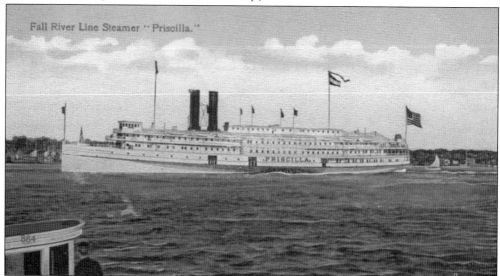

Fall River Line Steamer "Priscilla."

The steamers of the famous Fall River Line set standards for speed, efficiency, safety, dependability, and beauty. The company began in 1847 as the Baystate Steamboat Company, and the expanding enterprise of the line occurred in three decades following 1880. The *Priscilla* was built in 1894 at a cost of $1.5 million; known as the "Queen of the Sound," she served the fleet until its end in 1937. (Courtesy of Fall River Public Library.)

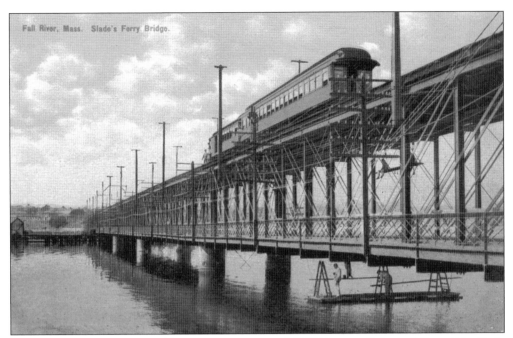

Ferryboats were used to travel between Somerset and Fall River until the building of the Slade Ferry Bridge, which opened in January 1876. William Slade established ferry service in 1689—first using rowboats, then sailboats, and finally, a boat propelled by horses that stagecoaches could use. The Slade Ferry Bridge was demolished in 1970. (Courtesy of Fall River Public Library.)

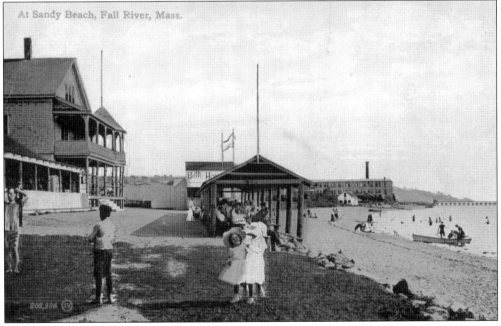

Sandy Beach was situated at the end of Bay Street and, before the 1890s, the area was known as Old Elm. Around 1892, the Dubois family developed the area into an amusement park and bathing spot. In 1930, a fire caused considerable damage, and a hurricane in 1938 completely destroyed the park.

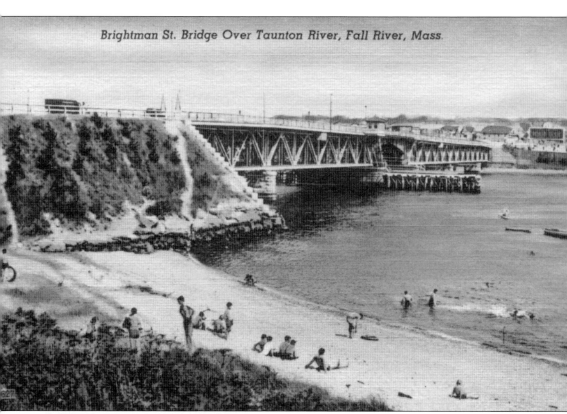

Brightman St. Bridge Over Taunton River, Fall River, Mass.

First opening on October 10, 1908, the Brightman Street Bridge passed over the Taunton River and connected Fall River to Somerset. It was 922.5 feet in length, and it carried Route 6 over the river. The bridge still stands today, but a new bridge, the Veterans Memorial, was completed in 2011, and Route 6 travels over it now. (Courtesy of Fall River Public Library.)

Nine

SOMERSET AND SWANSEA

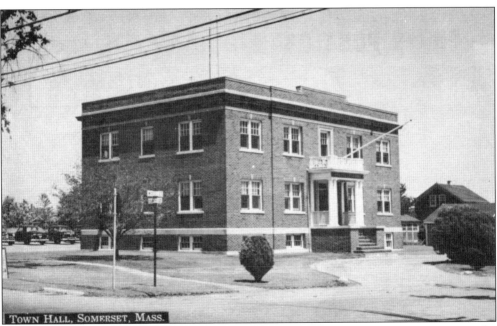

TOWN HALL, SOMERSET, MASS.

In 2011, the Veterans Memorial Bridge was built and is now what carries Route 6 over the Taunton River from Fall River into the town of Somerset. The town was founded in 1790 and derives its name from Somerset Square in Boston, the birthplace of the wife of the town's first moderator of its first town meeting, Jerathmel Bowers. The town hall, pictured here, first opened in 1927.

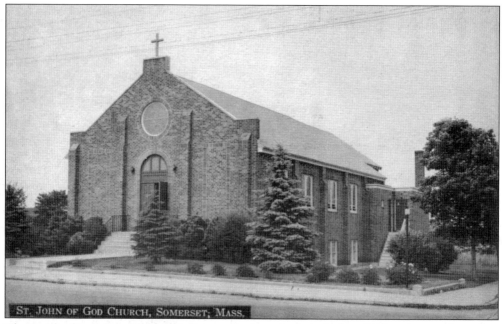

ST. JOHN OF GOD CHURCH, SOMERSET, MASS.

The Parish of St. John of God Church traces its roots back to the late 1920s, when services were held at Mello's Garage and the old town hall. Construction of this church began in 1928, and it first opened in 1930. In the late 1970s, a new church was built, and it stills serves the followers of St. John of God to this day.

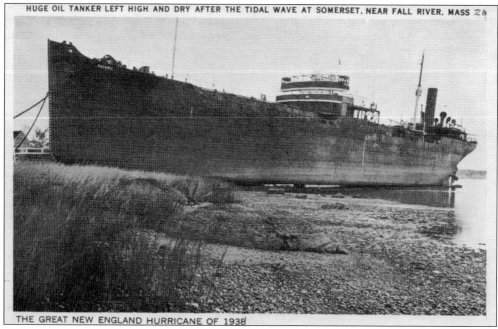

HUGE OIL TANKER LEFT HIGH AND DRY AFTER THE TIDAL WAVE AT SOMERSET, NEAR FALL RIVER, MASS 26

THE GREAT NEW ENGLAND HURRICANE OF 1938

On September 21, 1938, New England was devastated by a terrible hurricane. Over 600 people were killed, over 6,000 homes completely destroyed, and the cost of the damage was in the hundreds of millions of dollars. This freighter was forced adrift by the hurricane-force winds.

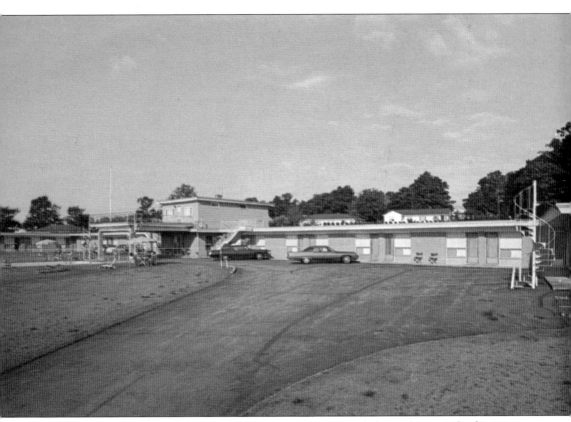

One of Somerset's main attractions is Pierce Playground and Beach, located just north of Somerset Marina. The Motel Somerset, facing the Taunton River, is now part of the Super 8 chain. Route 6 passes the Somerset Creamery and then crosses the Lee River into the town of Swansea.

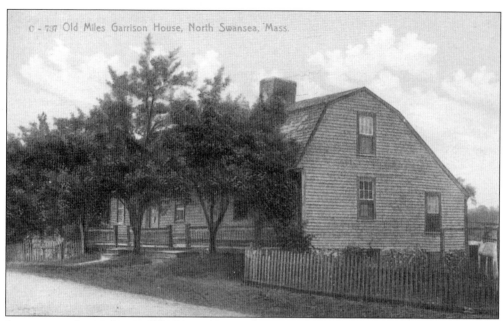

C - 737 Old Miles Garrison House, North Swansea, Mass.

Swansea was founded in 1667 by Rev. John Myles and Capt. Thomas Willett. Pastor Myles was the head of a Baptist church in England and religious persecution led him to Swansea. Soon, the new community built its first church, and the pastor's house built next to it was called the Myles Garrison House. Myles named the town after the area where he formerly preached in Britain—Swansea, Wales.

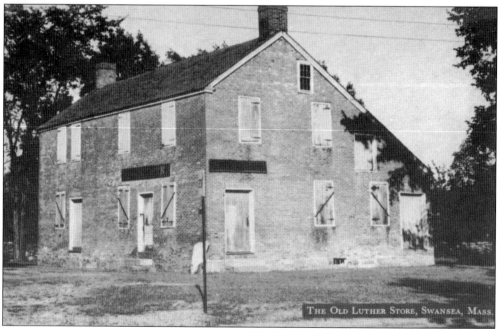

THE OLD LUTHER STORE, SWANSEA, MASS.

The Luther store first opened in 1815 and was owned by Joseph Gardner Luther. Until its closing in 1906, it sold hardware items, pipe tobacco, hats, and shoes, along with meat and fish from local farmers. In the 1930s, the store was given to the Swansea Historical Society, and it is now used by the society to preserve and inform the public about Swansea's rich history.

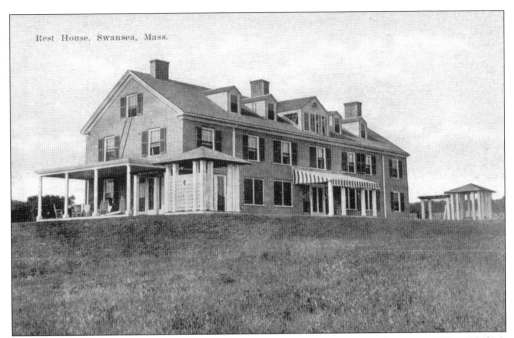

In 1675, Swansea was the site of the first bloodshed of what would be known as King Philip's War. Although the town was destroyed, the residents rebuilt, and ironworks, forges, and fishing were the main industries. A few taverns were built on what would become the future Route 6, and this is a postcard of the Swansea Rest House.

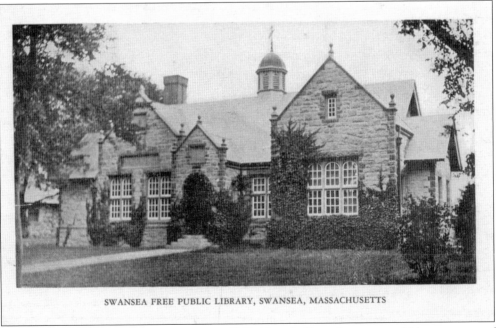

SWANSEA FREE PUBLIC LIBRARY, SWANSEA, MASSACHUSETTS

Arriving with his wife on Christmas Day 1858, Francis Shaw Stevens would become one of Swansea's most prominent citizens. Over the next 40 years as a banker, manufacturer, and state senator, he would make generous gifts to Swansea, including donating the capital for the town hall, Christ Church, and the library.

123

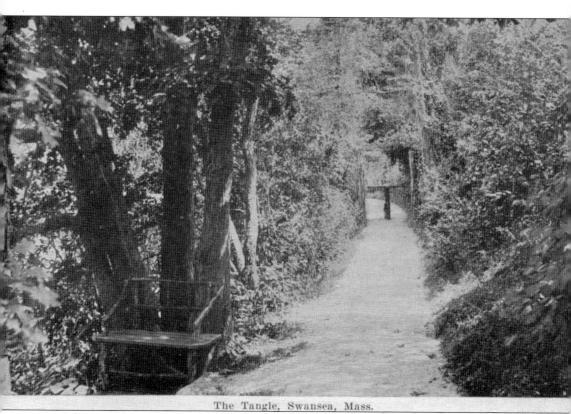

The Tangle, Swansea, Mass.

The Tangle was a series of beautiful gardens located on the Stevens Estate. When his second wife, Elizabeth Stevens, passed away, her will directed a home for boys be built upon her estate in memory of her husband. The Frank S. Stevens Home for Boys opened in 1939, and today, the dream of Elizabeth lives on through the Stevens Treatment Programs.

Ten

SEEKONK

From Swansea, Route 6 travels over the Palmer River, briefly through the town of Rehoboth, and into Seekonk. The town was famous for its historic fine dining restaurant called the Hearthstone House and Barn, located in a colonial house over 200 years old with a working fireplace. Guests enjoyed luncheons, teas, dinners, and a special Sunday buffet dinner. The restaurant has closed.

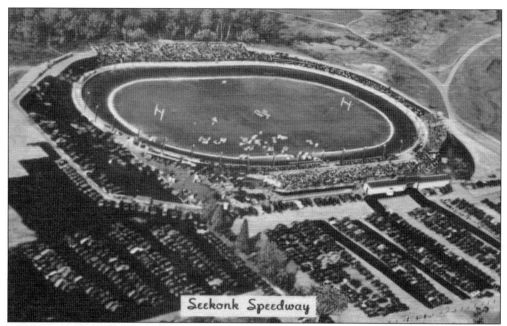

Seekonk Speedway

The major tourist attraction in Seekonk is the Seekonk Speedway, which opened on May 30, 1946. D. Anthony Venditti, known as the "Godfather of New England Auto Racing," owned, operated, and promoted the speedway until his death in 1991. Today, it is run by his son and grandson and is known as the "Action Track of the East." It is also home to the Seekonk Flea Market, which is extremely popular.

Three of the earliest Englishmen to settle in the area—William Blackstone, Roger Williams, and Samuel Newman—were seeking relief from persecution for their religious beliefs. Located on Route 6 is the long-standing Town 'N' Country Motel, which is still open today. A TGI Friday's restaurant sits directly in front of it.

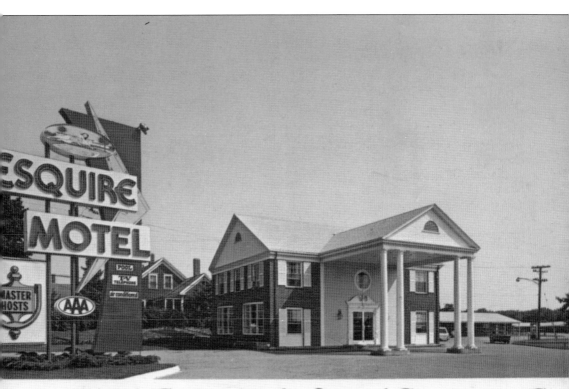

squire Motel, Rt. 6 = 4 miles East of Providence, R. S

Seekonk was incorporated as a town in 1812, and most historians agree that the name *Seekonk* is derived from two Wampanoag words: *sucki* (meaning "black") and *honck* (meaning "goose"). The 78-unit Esquire Motel was located across from the famous Darling's Restaurant, which first opened in 1929 but closed in 2010. From here, Route 6 travels about four miles before entering the state of Rhode Island and eventually going all the way to Bishop, California.

DISCOVER THOUSANDS OF LOCAL HISTORY BOOKS FEATURING MILLIONS OF VINTAGE IMAGES

Arcadia Publishing, the leading local history publisher in the United States, is committed to making history accessible and meaningful through publishing books that celebrate and preserve the heritage of America's people and places.

Find more books like this at
www.arcadiapublishing.com

Search for your hometown history, your old stomping grounds, and even your favorite sports team.

Consistent with our mission to preserve history on a local level, this book was printed in South Carolina on American-made paper and manufactured entirely in the United States. Products carrying the accredited Forest Stewardship Council (FSC) label are printed on 100 percent FSC-certified paper.

MADE IN THE USA